Charles Pfahl
Artist at Work

Charles Pfahl Artist at Work

BY JOE SINGER

WATSON-GUPTILL PUBLICATIONS/NEW YORK
PITMAN PUBLISHING/LONDON

First published 1977 in the United States and Canada by Watson-Guptill Publications,
a division of Billboard Publications, Inc.
1515 Broadway, New York, N.Y. 10036

Library of Congress Cataloging in Publication Data
Singer, Joe, 1923–
 Charles Pfahl, artist at work.
 Bibliography: p.
 Includes index.
 1. Pfahl, Charles Alton, 1946– 2. Painting—
Technique. I. Title.
ND237.P45S56 759.13 77-8693
ISBN 0-8230-0620-4

Published in Great Britain by Pitman Publishing
39 Parker Street, London WC2B 5PB
ISBN 0-273-01147-3

Manufactured in Japan

First Printing, 1977

Charles Pfahl and Joe Singer
dedicate this book
to Dora and John Koch

Contents

FOREWORD 9

INTRODUCTION 11
THE CONCEPT 13
POSING AND COMPOSING 14
LIGHTING THE SUBJECT 20
COLOR 23
TOOLS AND MATERIALS 28
HOW PFAHL PAINTS IN OIL 33
PFAHL DRAWS WITH PASTEL 37
FRAMING THE PICTURE 37

DEMONSTRATIONS 41
DEMONSTRATION 1: A FEMALE NUDE 42
DEMONSTRATION 2: A CLOTHED FEMALE FIGURE 53
DEMONSTRATION 3: A FIGURE IN AN INTERIOR 64
DEMONSTRATION 4: A MALE NUDE 83
DEMONSTRATION 5: AN INTERIOR 95

ONE-MAN SHOW 103

BIBLIOGRAPHY 141

INDEX 142

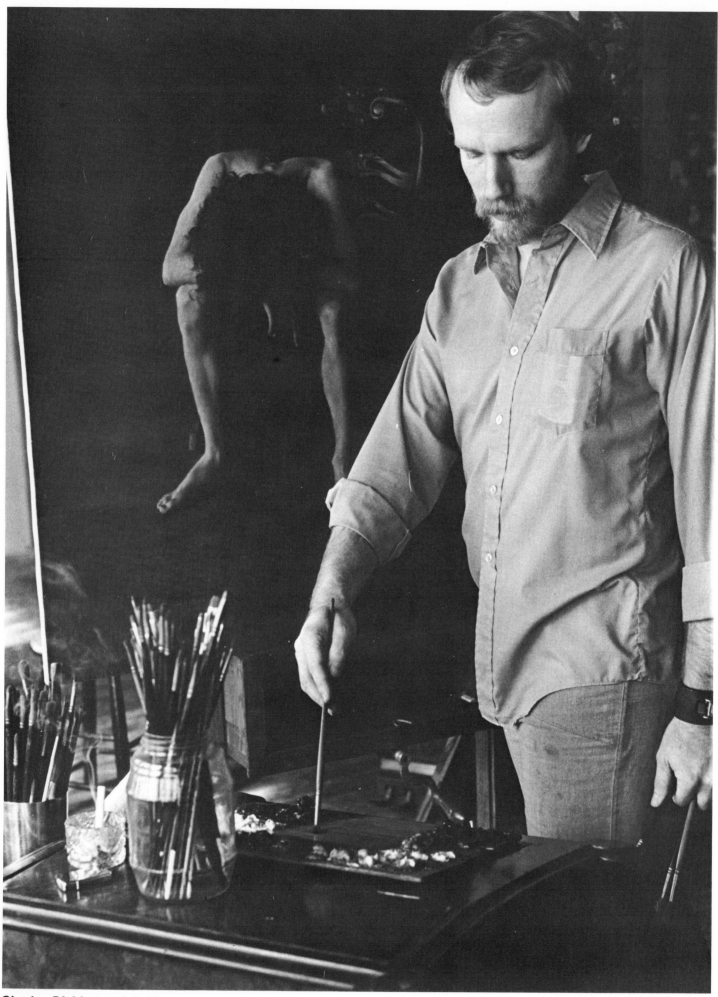

Charles Pfahl at work in his studio.

Foreword

Charles Pfahl is a young artist painting in the realist tradition, whose work is heavily weighted toward the figure and somewhat less so toward the interior and still-life painting. This book affords you the opportunity to stand at his side and watch over his shoulder as he creates—from beginning to end—paintings of a female nude, a clothed figure, a figure in an interior, a male nude, and an interior without the figure. You also learn how he proceeds from initial idea to preliminary sketch to tone or color sketch, and finally, to the finished painting. Pfahl speaks in detail of the factors that stimulate and fashion his concepts, of how he puts these concepts into concrete form, and of the tools and materials he employs to achieve his results. The book thus provides valuable insight into the concepts, procedures, and techniques of an outstanding painter, information that you may profitably apply to your own efforts.

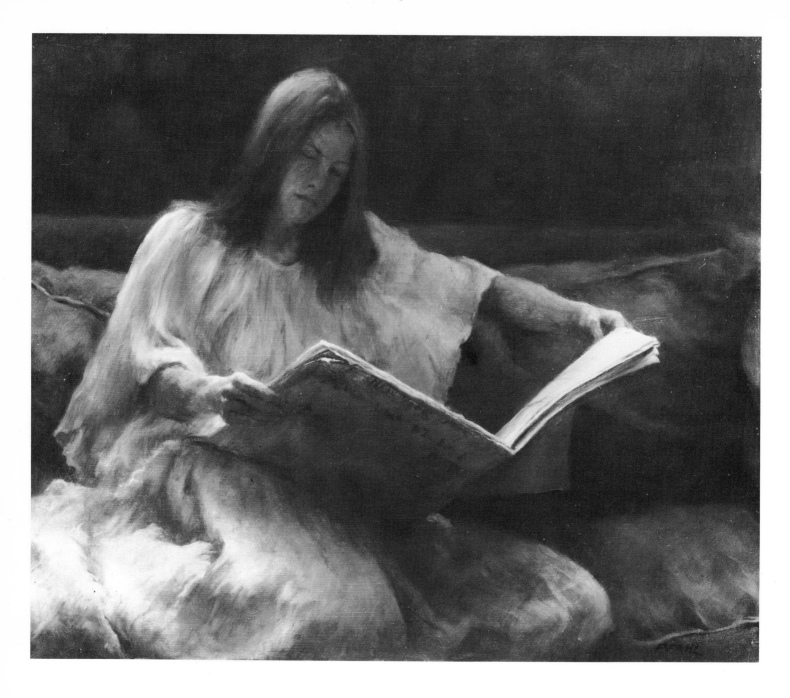

Sunday Morning. Oil on toned panel, 12'' x 15'' (30.5 x 38cm), collection of Mr. and Mrs. David Winterman. This was one of a series of paintings Pfahl did of models in dress that particularly intrigued him. Several of these appear in the book. In each case, it was the character and flow of the material, the way it formed into folds, and the shapes it assumed that inspired Pfahl to do the painting, rather than the person who was wearing it. Pfahl often becomes interested in a specific subject—animate or inanimate—and proceeds to paint it in a variety of poses and situations.

Introduction

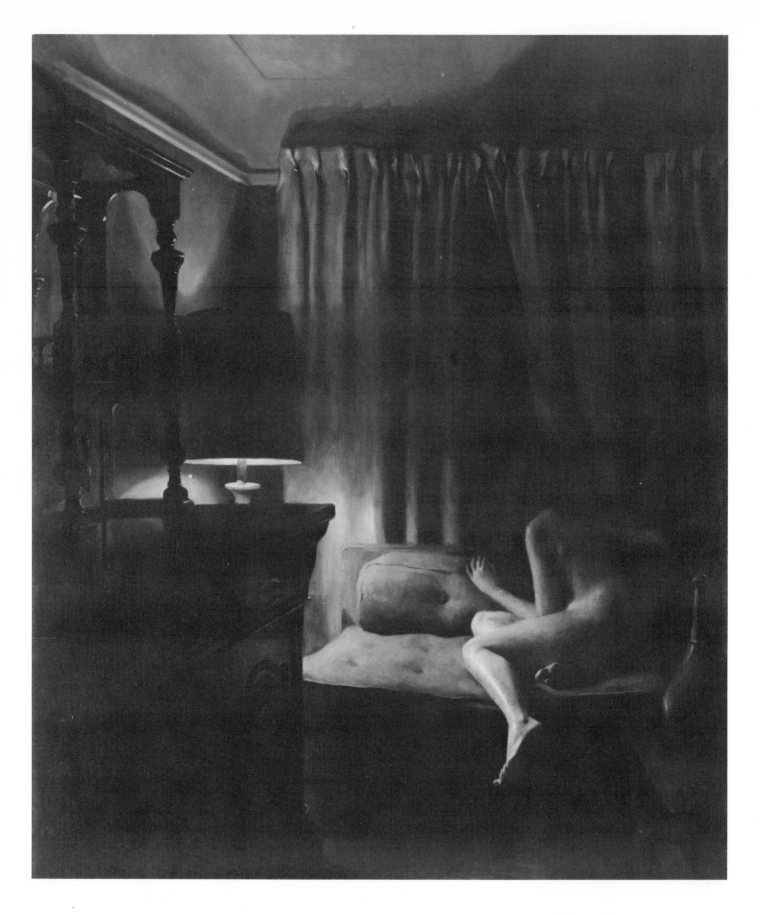

Night Light. Oil on untoned canvas, 30'' x 25'' (76 x 63.5cm), collection of Dr. and Dr. Spatz. Pfahl lined the lampshade with newspaper in order to reduce some of its brightness, placing additional paper on top of the shade to cut down the shaft of light projected onto the ceiling. This is a device Pfahl picked up from his good friend and teacher, John Koch. The eerie mood of this picture might have been destroyed or minimized had a bright blaze of light emanated upward, since the overall effect Pfahl sought was the concentration of light toward the center portion of the canvas.

The Concept

One of the most significant insights into an artist's way of working is the knowledge of where and how he obtains his ideas; what sights, events, or circumstances serve to plant the seeds that will eventually germinate into paintings. Let's consider some of these sources.

The Environment as a Source of Ideas. Charles Pfahl lives in a sprawling West Side, New York, loft that occupies an entire floor and serves as a combination studio and apartment. This is where Pfahl spends most of his time, and it is a rich source of inspiration from which he again and again draws ideas.

This dramatic environment reminds one of a movie set where, by constantly shifting backdrops, furniture, and props, ever new arrangements are assembled to simulate various settings and situations. Pfahl periodically rearranges the studio's furnishings, a device that stimulates the flow of his creative energies and opens new vistas of inspiration and imagination.

Ideas Through Observation. A second source of ideas for Pfahl is his power of observation. Wherever he finds himself—in the street, the restaurant, the subway—Pfahl constantly observes the way people sit, move, walk, talk, and generally comport themselves.

He may be struck by the way a person's head appears against a certain light or by the way a figure seems to turn. He will then record this impression in a sketchpad right on the spot, if this is possible, or retain it in his mind to be put down on paper when he gets home. One day, he may incorporate that impression into a painting, or construct a whole composition around it.

The Process of Selection and Elimination. Periodically, Pfahl goes through his file of recorded notes—some possibly years old—weeds out those that seem inappropriate, and gives further study to those that have retained their interest. At such times, seeds of ideas are planted and it is merely a matter of time until one takes growth. It may be a visual impression that has persistently intrigued him or a fresh idea that emerged from some other response. Whatever the case, after long and deliberate thought, Pfahl formulates a definite concept and he takes steps to carry it further.

Developing the Concept. Pfahl now proceeds in one of several ways. He may select a model and have him strike a number of poses against various backgrounds. Pfahl then sketches him in the different situations until one pose takes firm hold. Or he may take the initial, very rough idea sketch, carry it further in sketches, *then* bring in the model once he is fairly sure of the direction in which he wants to proceed. In the same vein, Pfahl may compose the total painting first and incorporate the figure into it later, or pose the figure first and compose the painting around it.

All this may still not produce a definite commitment to proceed with a painting, since it may turn out to serve the very opposite purpose—to convince Pfahl that he is embarking on a futile course. But it also happens that an idea is tested, rejected, put aside, and then revived again some years later. Pfahl, therefore, considers all such preliminary activity as useful, even if it doesn't result in an immediate painting.

Assuming, however, that all works well, Pfahl proceeds to further develop and refine the concept. He is not a swift, impulsive painter, splashing paint on canvas in the heat of artistic fervor. Rather, he works in a slow, deliberate fashion, planning and carefully considering each progressive phase of the picture.

Posing and Composing

Too many painters simply load up a palette, pick up a brush, nod to the model to stand or sit, and commence painting. This hit-or-miss approach couldn't be less characteristic of Charles Pfahl, who devotes hours, even days, to planning the specifics of the pose and design for his paintings. Here are the ways in which he proceeds.

Choosing the Pose with a Preconceived Concept. Even though a pose may appear splendid to the eye, there is no assurance that it will work on canvas, since a correctly drawn limb doesn't necessarily insure a pleasing visual element in the painting.

It is therefore vital for Pfahl to first pose his model according to his preconceived concept, and then to make some fairly accurate drawings of the figure to see if the pose can be used successfully in the picture.

This involves a pencil study in which the contours, proportions, and patterns of light and shade are pretty thoroughly worked out. If no apparent obstacles crop up, Pfahl feels encouraged to proceed with the pose. If not, he has the model move about slightly and makes additional drawings until the problems are resolved.

In this situation, since Pfahl has already decided on the other elements in the painting—background, props, etc.—he confines his drawing to the figure itself.

Choosing a Pose without a Preconceived Concept. In cases where Pfahl has not yet decided the concept of his painting, but is relying on the model to help suggest one, he has the model strike various poses until something clicks. *Then* he proceeds with an accurate figure study. This entails working with a model who moves about freely and will go through a number of poses without complaint.

The whole time the model is assuming the different poses, Pfahl continues

to sketch quickly, merely to obtain the general feel of the pose. Many such sketches are tucked away in his file for future reference.

Sometimes the answer as to the final pose emerges during the rest period when the model falls naturally into a pose that will immediately intrigue the artist. But even if the pose not only looks right to his eye but also looks good on paper, Pfahl still moves all around the model in order to study the figure from various viewpoints. Since it is the light that determines the breakup of value patterns on the subject, Pfahl naturally wants to view and paint the model from the most advantageous angle.

Working with the Live Model. Pfahl has conflicting feelings about selecting models for figure work. Although he enjoys working with people he knows and has rapport with, it often happens that a friend lacks the flexibility and adaptiveness of a professional model. This is where drawing serves its purpose. By carefully analyzing all aspects of the pose and by planning and resolving in advance such elements as color, values, and composition, leaving nothing to chance, Pfahl avoids the hardship of having to make changes in the pose once the painting is fairly well along.

Until now, Pfahl's preference for models for his figure work has been for those with pale skin and often gaunt bodies that reveal the bone structure. He avoids those with ruddy or suntanned complexions since he finds that the cool, milky skintones harmonize best with the somber, dramatic tones in his paintings. He also prefers cool skintones since he likes color schemes containing mixtures of greens, blues, purples, and grays.

Arranging Interiors. Pfahl paints interiors both with and without a figure. Frequently, just by altering the arrangement of the furnishings in his studio, he is struck by some particular view or angle of a part of his environment, and is tempted to put this down on canvas. He may be attracted by the very lack of life suggested by an interior—by its abstract quality—or may feel compelled to add a figure in order to provide it with the animation it may lack.

Whatever the case, Pfahl does not simply sit down and copy an interior as is. He first studies it carefully from every angle, seeing how the light strikes it from this or that viewpoint, and analyzing what elements it lacks or contains. Then he adds, subtracts, or rearranges objects until the final arrangement suits his concept. Even then, he sits down and draws the scene several times until it appears correct not only visually, but artistically as well.

Arranging the Interior with a Figure. As just mentioned, the figure can be an integral part of an interior painting, or an incidental element in it. The demonstration of the male nude on pages 83–93 is an example of the former; the demonstration on pages 64–82, an example of the latter.

In the first example, the figure dominates the entire painting; in the second, our eye is drawn to the figure which occupies the most significant, though not *the* largest area of the picture. There is a lengthy expanse of rug up which the

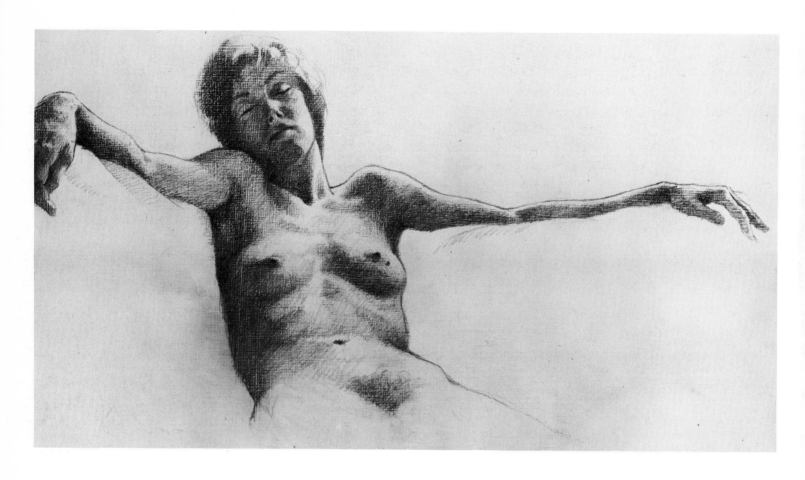

Nude (study). Hard pencil on gessoed Masonite, 5½'' x 9½'' (14 x 24cm), collection of Mr. and Mrs. Anthony Mysak. This is the pencil study that led to the painting on the following page. This difficult pose so intrigued Pfahl that, after completing the pencil study, he reversed it for the oil painting, further extending the arms and increasing the tension in the pose. Pfahl likes to work in pencil on Masonite that has first been primed with gesso. The surface produces a line somewhat similar to that achieved in silverpoint drawing, where a metal stylus is used to scratch out the lines.

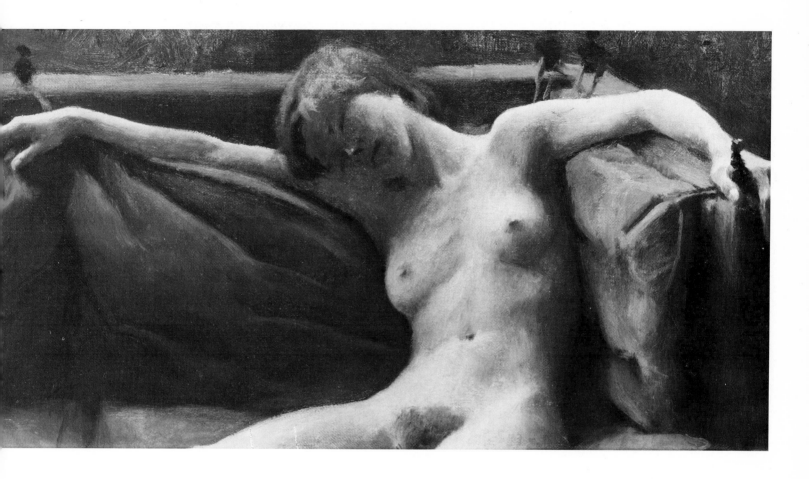

Nude. Oil on untoned canvas, 8" x 12" (20.5 x 30.5cm), collection of Mr. N. Delman. The effect of the figure on the cross is very much present here. Although the head is apparently relaxed, there is tension in the widely extended arms. No person would doze off in such a pose—it would be too uncomfortable. The technique here is somewhat rougher than usual. Whether this suggests a trend is hard to say, because he has since painted pictures in tighter, more finished fashion. Perhaps he varies his method from time to time to experiment and to fully test the extent of his abilities.

eye must first sweep to arrive at the figure. Also, the figure occupies a relatively small area of the painting.

Pfahl considers the degree of importance he wishes to assign to the model when he plans an interior with figure, and proceeds accordingly. All the elements—size, placement, and lighting of the figure—dictate this consideration.

Composition. Although he is familiar with all the rules and theories regarding composition, Pfahl does not take them too seriously, since he is aware that many successful paintings contradict these very rules.

Since Pfahl works essentially with lots of atmosphere and avoids crowded, busy subject matter in his paintings, he is very conscious of where he places his limited number of pictorial elements. He often places a small cross in the center of his canvas, then deliberately decides whether to place his subject off center or in the middle of the canvas. His approach to composition is to try to balance the smaller mass, which is the subject, within the larger areas of air and space that surround it.

Since each picture obviously dictates its own individual design, Pfahl avoids habits and stock compositions—he plots a fresh, striking composition each time he launches a new canvas.

Setting Up the Still Life. Although this book deals mainly with Pfahl's treatment of the figure, it is interesting to touch on his approach to other subject matter in order to gain a larger overview of the way he thinks and works.

When it comes to still life, Pfahl does not just stack a bunch of apples and grapes in a bowl and splash away at a canvas. Instead he is often inspired to paint a still life through some visual stimulus that occurs as he wanders through his large studio. He may suddenly be attracted by the shape, texture, or color of an object he may have seen hundreds of times before without really noticing it. It even may be the way the light strikes it at that particular moment that triggers the positive response.

Were he to follow the first approach—simply grouping objects for the particular purpose of arranging a still life—he would end up painting merely objects without personal feeling or intimacy. However, through his particular approach—first being inspired by an idea, a concept, or visual experience before he paints—he ends up doing not a still life but a *portrait* of a subject that only incidentally happens to be inanimate. Pfahl seeks an attachment—a personal response—to the mood, color, and pattern of light and shade the object projects.

In setting up a still life, Pfahl prefers simple arrangements to more elaborate ones. He might move the desired object from its usual place in order to light it better, but he would not group dozens of incongruous objects around it merely to achieve variety or more color. His tendency might be to paint the object alone at its best.

Selecting the Size and Shape of the Canvas. Pfahl keeps a number of stretched and toned canvases and boards of various shapes and sizes in

readiness in his studio. This affords him the opportunity to proceed immediately with the painting once he resolves the decision regarding size and shape. However, this decision is always predicated on the idea of the painting, and it is not made until the concept is visualized in preliminary sketches and drawings.

Pfahl makes decisions regarding size and shape purely through instinct. He is periodically seized by urges to do massive paintings, impulses he cannot always translate into practical terms. There are, however, certain considerations dictating some of these decisions.

For instance, Pfahl has most recently felt inclined to do really large paintings of nudes. He is anxious to capture the sensation of the person being capable of getting up and walking out of the canvas. This idea, which would not work very well with a 6″ (15 cm) figure, therefore dictates that the figure be lifesize or nearly so.

Another of Pfahl's conceptions is to someday execute a still life of crystal and silver on an enormous canvas. This idea has been brewing in his mind for a long time and is bound to be translated into a painting sooner or later. Pfahl contends that working on a large scale is no harder than working on a small one and is possibly even easier, since depicting detail on a miniature form is certainly more difficult than in a lifesize painting.

His choice of size is also affected by the type of paintings he contemplates doing. Landscapes and figures allow for the widest latitude of size, while portraits and still lifes allow for the least. However, he is hesitant about painting objects larger than lifesize because they can lose their sense of reality.

In order to select the best size and shape canvas for each painting, Pfahl recalls that he used to divide a sheet of paper into various sizes and shapes of squares and rectangles, and fit his thumbnail sketches of a projected painting into each to see where it would work best. However, these days he is more apt to rummage through his selection of prepared boards and canvases and simply choose the one that seems most appropriate to the concept—more a matter of instinct, feeling, and intuition than plan.

He does point out that he would hesitate to attempt a large, complex canvas without lengthy and careful preparation. This might involve many thumbnail sketches, line drawings, tonal drawings, and possibly, color impact sketches, which will be discussed shortly.

For a simpler concept that requires less preliminary activity, he might choose a smaller canvas. This would permit easier alteration or even a completely fresh start if problems occurred.

The Tonal Study. We have already seen that Pfahl makes numerous drawings as part of his preliminary procedure, before laying a single brushstroke. When he has satisfied himself that the pose can be successfully transferred to canvas, he often makes a careful tonal drawing or several drawings in carbon pencil on vellum paper. In these value studies he works out not the problems of pose, but the patterns of lights and darks as they fall on all the masses and forms in the subject.

Lighting the Subject

Since Pfahl does little landscape painting, the bulk of his work is executed inside his studio. He is fortunate to be able to work in an area that is hundreds of feet square. In a sense, that studio is his subject, since almost everything he paints includes parts of it, and he rarely gets painting ideas elsewhere.

Painting in Daylight. Thus, the light that Pfahl uses most often is that coming from the long row of windows that completely lines two sides of his studio and faces both north and south. The southern exposure does present some problems on bright, sunny days, since he leans toward dark, somber lighting and generally tries to avoid sunny illumination.

Since the basic emphasis of his painting is on color, he favors the cool, constant daylight that his cool northern exposure provides. This gives him the wide range of tones and hues he desires. This is particularly important when he is painting flesh, which shows up its variety of colors best in daylight.

However, Pfahl makes a distinction between *natural* and *artificial* light, according to his conception of the term. To Pfahl, natural light is either daylight or electric light from an ordinary, incandescent bulb. Artificial light, as he sees it, is a flourescent light or electric light that seeks to *mimic* daylight. He never paints under fluorescent light. If he wants to employ electric illumination, he switches on his incandescent lamps and lets them light both his subject and his canvas. He finds that artificial (fluorescent) light tends to kill the colors in the subject and rob them of their intrinsic freshness and excitement. Incandescent light, on the other hand, while cancelling out some of the color—particularly the cooler tones of the subject—appears proper and right within its normal night setting.

Pfahl's tastes in colors and subject matter run to cool colors abounding in bluish and purplish accents. He tends toward grays and to subjects presenting a full range of values from the darkest darks to the lightest lights. For this reason, when doing figure studies, he selects models with very pale, neutral skins, rather than those inclined to be pink and florid. Seeking a high contrast of values, he usually poses these models deep inside the room on sunny days, and closer to the window—his favorite type of illumination—on sunless days. He tries to make sure that there is always enough light falling on the *light* side of the subject, since he finds all the exciting colors within these light areas. Posing his subject in semi-darkness would negate the very effect he is after.

To provide this vital contrast between light and dark, he painted all the walls in his studio a middle tone and has a number of dark screens in reserve to help bring out the light areas and to kill any reflected light that might vitiate the deep shadows he prefers.

In lighting his subject, he always tries for a *natural* effect, whether the light is daylight or electric. He always tries to arrange the model or the lighting in

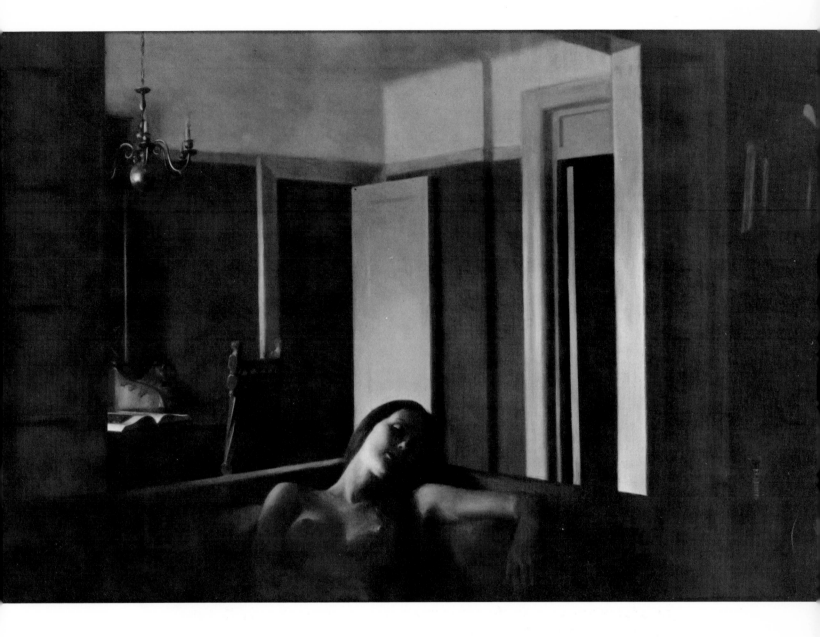

Model at Rest. *Oil on untoned board, 14" x 22" (35.5 x 56cm), collection of Greenshields Museum. Here, Pfahl plays the curves of the resting model against all the vertical and horizontal shapes stacked in the room behind her. The lights are subdued throughout and an air of quiet repose seems to envelope everything. This painting required a keen awareness of perspective because of the many angles formed by the receding planes of the doors, walls, and ceiling. Pfahl placed the woman's head in almost the exact vertical center of the picture. He often does this intentionally, to achieve a desired effect.*

such a way that it will present a full range of values, including the darkest shadows, lightest lights, and neutral middletones that best serve Pfahl's chiaroscuro approach to painting.

Electric Lighting. Pfahl does a fair number of night scenes, many of them interiors with or without a figure. When he paints such a scene, he employs the lamps that normally light his studio. He hesitates to use spotlights, floodlights, or any other gimmicky sources of light, since this would clash with the naturalness he seeks in all his work.

To maintain this natural effect, he uses the same incandescent lights to illuminate his canvas and palette. While electric light does affect the color of everything it strikes—making colors darker, warmer, and more limited in range—he takes these factors into consideration and paints the subject as it appears. Since the quality of light striking his palette, canvas, and subject is the same, it results in a painting that appears natural—natural, that is, within the context of electrical illumination.

When he paints a subject in which both daylight and electric light are present, he makes sure that his palette and canvas are illuminated by the daylight, since this is always the dominant light in any painting situation in which there are two kinds of light.

Manipulating the Lighting. When painting in daylight, the only manipulating he might do to the lighting is to place a screen somewhere to block off one or more windows, or to darken an intruding light background or some other source of reflected light. However, when painting at night, he might wrap several sheets of newspaper around the lampshade if the lamp throws too much light—increasing the number of sheets in proportion to the amount of light he wants to kill. He might also use newspaper to cover the top or the bottom of the shade and keep the light from shining up or down, or to aim the light in a certain direction.

Generally, however, Pfahl tries to gain the desired effect by moving the figure about within the range of established lighting in the studio, rather than by manipulating the lighting itself. He also prefers to leave his furniture, plants, and other furnishings in their normal position and instead adjust the figure accordingly, within this set environment.

Direction of Light. The basic lighting Pfahl uses when painting in daylight is the side lighting that enters through the bank of windows lining his studio. He does not have a skylight nor does he use shades to raise or lower the direction of this light. Lights issuing from above tend to lend a theatrical, artificial quality to the subject; he prefers the natural effect that side lighting provides.

He often poses his models in half or three-quarter lighting so that their shadows go deep and their lights become especially light. He likes these deep shadows, and treats them as a single mass. He finds that side lighting is best to produce these powerful darks.

Like top lighting, Pfahl finds that lighting from below is sometimes tricky

and theatrical, and frontal lighting can give a dull, vapid appearance to a subject. But he will use either of these lighting effects if it happens to suit a particular concept.

Occasionally, he employs backlighting to create strong patterns of darks against the light areas. However, in painting interiors that include some backlit elements, he makes sure that the sidelit areas are kept down in value so that they don't compete with the effect of the light surrounding the backlit patterns.

It is most difficult to render the lighting on objects shown simultaneously inside and outside the studio. In such cases, Pfahl finds it useful to glaze over the inside objects to bring down their values.

Outdoor Light. On occasion, Pfahl paints outdoors. But while the subject itself may be in bright sun, he always sets up his canvas and palette in a shady spot. He does not paint in the sunlight itself because if he uses untoned canvas, the sun will cause too much glare on the white surface. He also finds that he cannot judge the colors on his palette correctly when they are struck by the full light of the sun.

There are several unique factors in outdoor lighting. First, there is generally no black present anywhere in an outdoor setting. Second, shadows go much higher in value. Third, lights must be painted darker and darks lighter than they actually appear on location. Fourth, objects outdoors are grayer than you might assume at first. Fifth, the grayness created by outdoor atmosphere holds true even at very short distances.

Pfahl finds that he can judge the accuracy of an outdoor painting only after he has taken the painting inside. Once inside, he sometimes finds that he has painted his darks too dark and has given the painting too much contrast. Taking the painting out on location again and bringing up the darks will usually correct these lighting errors.

Color

No factor of painting is more important to Pfahl than that of color. Just as in every other aspect of his work, his approach to color is studied, analytical, and deeply and carefully considered. It begins with the choice of the tube colors.

Palette of Colors. Pfahl is essentially a colorist. He paints in a wide range of hues and values and, rather than consciously limit his palette, uses as many shades of paint as possible to achieve the desired effect. For a recent painting of roses, he obtained every red shade available and used each one to try to approximate the intensity of the flowers themselves. He keeps an extensive assortment of shades handy and dips into it whenever he is challenged by some particularly unusual color.

The reason Pfahl requires so many colors is that he *sees* so many colors—many more than the average person or even the average artist. Looking at a gray wall or a white cloth, Pfahl sees there every color in the spectrum. This is a faculty he developed from intense study and training, and it is one he tries to pass on to his own students. Since he seeks to reproduce with fidelity the many colors he sees, Pfahl knows no good reason for limiting his palette. Instead, he is constantly testing and trying new colors, with the only limitation being that they be restricted to those designated as permanent.

Despite this quest, Pfahl has settled on a more-or-less regular palette to which he adds additional shades should the situation warrant it. The regular palette, all Winsor & Newton colors except where noted, consists of:

flake white #2	cadmium red light
Naples yellow	cadmium red deep
raw sienna	alizarin crimson
light red	manganese violet (Shiva brand)
Indian red	Winsor violet
burnt sienna deep (Blockx brand)	cerulean blue
ivory black	ultramarine blue deep
lemon yellow or cadmium yellow pale	sap green
cadmium yellow medium	viridian green
cadmium orange	

Approach to Color. Pfahl is inclined toward the blue, green, and purple shades and stocks a large supply of these colors. He also is keenly alert to the intensity any color projects. Since he is aware that the intensity of one color is deeply affected by the value and hue of the colors that surround it, he incorporates this phenomenon in his paintings. He can then render areas of color more or less intense by heightening or lowering the intensity of those colors lying next to them. At times, in the final stages of a painting, he may glaze an area to change its hue; but normally he glazes only to lower value.

Pfahl *thinks* like an Impressionist, but does not paint like one. A former student of Robert Brackman and of Jack Richards, who also studied with Brackman, Pfahl learned from both men not only to see patches of different color in every subject, but also to paint this effect accordingly. He maintains that if you look long enough at any object, it will project every color, since the light that strikes it possesses every color. The only decision that the artist must make is just how much of any color to put into the painting, since technically, the process can go on practically forever. Obviously, some system of elimination must be adopted. It is a message Pfahl imparts again and again to his students.

Color in Pastel. Pfahl uses pastel essentially as a preliminary tool for his oil painting, not as a painting media in itself. He differentiates between pastel painting and pastel drawing as follows: *Pastel painting* implies creating an atmosphere by filling in the paper with tones and colors of your choice. *Pastel*

drawing means using the tone of the paper as the atmosphere from which the figure emerges.

By his own definition, Pfahl *draws* with pastel. He uses hard pastels of the Henri Roche brand, a French import that is expensive and most difficult to obtain in the United States.

In any case, because he draws rather than paints with the pastel sticks (painting with them would abrade them faster), Pfahl still maintains a major portion of the original 500-stick selection in his set. He lays them all out and may use every shade when he works. He likes this particular set because it contains fewer harsh and raw-colored shades than do the conventional pastel assortments, and for the fact that their hard consistency allows him to draw them more easily than would be the case with the softer pastels.

The Key. Pfahl is neither a high-key nor a low-key painter. His values usually range between a very high light and an extreme dark. He never consciously varies his key but it does undergo change based upon the elements presented by the individual subject.

Nor does Pfahl pre-arrange color schemes. He sets up the subject to his satisfaction and then paints exactly what he sees. He might, however, lower the true value of an area by glazing in order to bring up the lights in an adjoining area to which he wishes to direct the viewer's eye.

Warm and Cool Color. Pfahl is aware of warm and cool colors, but he does not deliberately seek to achieve a balance of these on his canvases. He does feel that daylight (barring sunlight) does cast cool color, much cooler than most observers acknowledge, and Pfahl seems particularly responsive to these accents.

Because he *sees* mainly cools, he paints accordingly and seldom goes to the warmer reds. Particularly when painting the figure, he is least apt to dip into the stronger cadmium colors, since he finds that merely a subtle touch of warm color is all he needs to warm up his essentially cool flesh tones. He does feel that color perception is personal and individual, which is the reason his eye chooses to skip the reds in his subject or, at least, to minimize their presence.

At one time, he leaned more heavily to purple accents in skintones but today, they are apt to be less obvious. It is not that he is seeing less of the purples, it is that his general technique is growing looser and simpler. He tends to work more with strokes of broken color, laid down in subtle fashion. He is still very much aware of the presence of detail, but *he has stopped looking for it*. This is a natural evolution of every painter's development: as one grows older and more experienced, the normal tendency is to loosen up, soften, and simplify. Pfahl finds that he can now approximate the illusion of reality with a minimum of strokes, as compared to his earlier technique.

Color Impact Sketches. When contemplating a large and important painting, Pfahl will often do a series of advance color studies that he calls impact

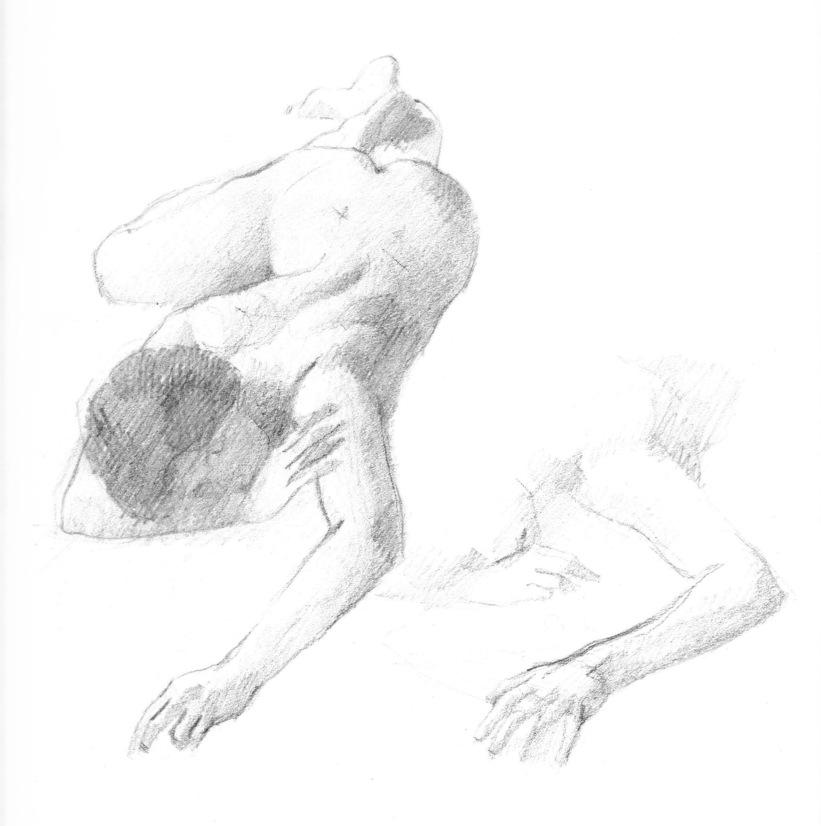

Nude on Carpet (study). Pencil on paper, 14'' x 11'', collection of the artist. These are some of the sketches Pfahl executed in planning the subsequent oil painting. Notice the three different ways in which the left arm is positioned, demonstrating how Pfahl searched for the angle and design that best expressed his conception of the picture. Pfahl does drawing after drawing until he is satisfied that every element of the pose is correct. Many painters—especially the young—are too impatient to expend so much energy on preliminary effort and leap right into the final painting, with often chaotic results.

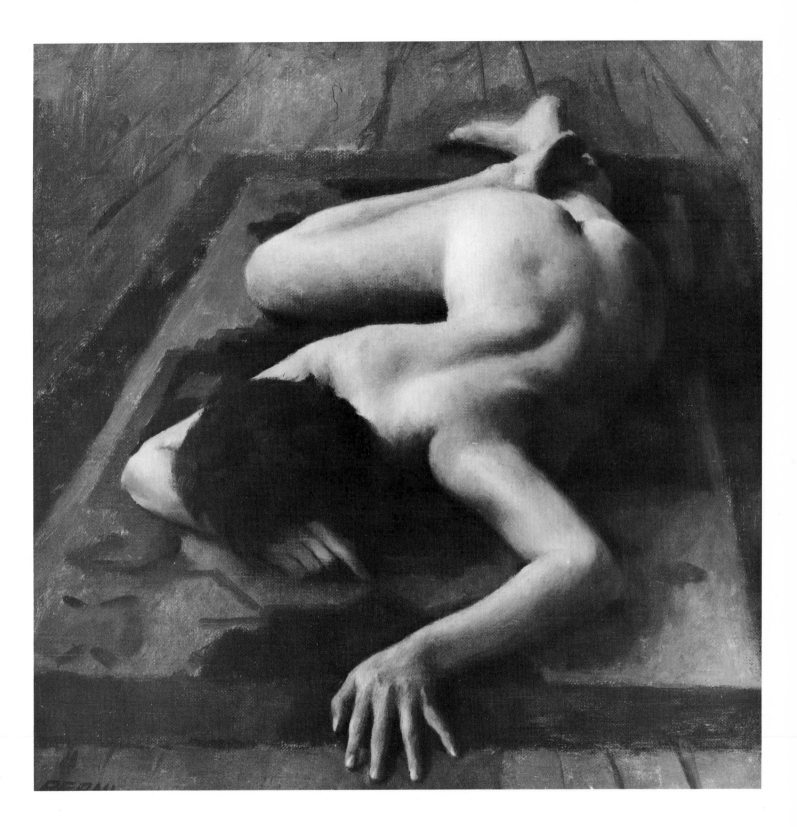

Nude on Carpet. Oil on untoned canvas, 10'' x 8'' (25.5 x 20.5cm), collection of Ms. Devon Young. It is hard to conceive of this painting being only 10'' x 8'' (25.5 x 20.5cm), since it appears much larger. By proportioning the figure to the scale of the work, Pfahl gives the illusion of greater size. In this painting Pfahl departs from his usual practice of finishing off every portion of the picture—the carpet and floor are left relatively rough and undone. This represents a direction that Pfahl feels he will be following more and more—concentrating on the main aspect and merely indicating loosely less important areas of the painting.

sketches. These are executed to let Pfahl see how the whole thing will work in color. They are usually done in oil on a small canvas or board, and may take no more than two hours to execute.

In his impact sketch, Pfahl puts down roughly all the major components of the subject and works out the patterns of lights and darks in color. He then studies these basic color relationships and decides whether he will proceed with the painting as is, or whether he will introduce changes in lighting, composition, or whatever.

For figure paintings, he might also do such a study in color, using pastel. But he also anticipates a time when he may use sculpture to execute this type of impact study.

Since color and value are basically similar factors, the color impact sketch serves simultaneously as a tonal relationship study as well as a color study for Pfahl.

Regardless of whether he has prepared black and white or color sketches, Pfahl always keeps such preliminary studies handy when he paints the actual picture. The sketches help keep alive that important first impression the subject originally presented and provide a true indication of the coloration as seen and done from *life*, rather than from a camera's distorted view.

Tools and Materials

An artist who is conscious of his worth strives to preserve his work for future generations. He certainly owes such an obligation to those who show their appreciation by purchasing his pictures. Conscious of this responsibility, Pfahl uses the best available tools and materials for his paintings.

Colors. Pfahl uses Winsor & Newton oil colors plus a few shades from other brands he finds particularly useful, namely a Blockx burnt sienna deep and a Shiva manganese violet. With rare exceptions, he uses only permanent colors in his palette.

Surfaces. Pfahl's favorite canvas is a Fredrix # 111 D. P. Rix, which is a fine double-lead-primed Belgian linen. He often tones this canvas with a transparent mixture of ivory black and Maroger medium (producing a silvery gray effect). Occasionally, when he wants to work on a smoother surface, he adds white to the mixture. Because it is heavy and opaque, the lead white covers the tooth of the canvas more, creating a slicker surface.

Pfahl staples the canvas to the stretchers. For canvases larger than 30″ (76 cm) he uses double-width stretchers with a crossbar for extra support.

Pfahl also uses Masonite in ¼″ (6 mm) widths in paintings up to 16″ x 20″ (40.5 x 51 cm). He primes these boards with four coats of white acrylic gesso, sanding the surface between each priming. Finally, he tones them with a mix-

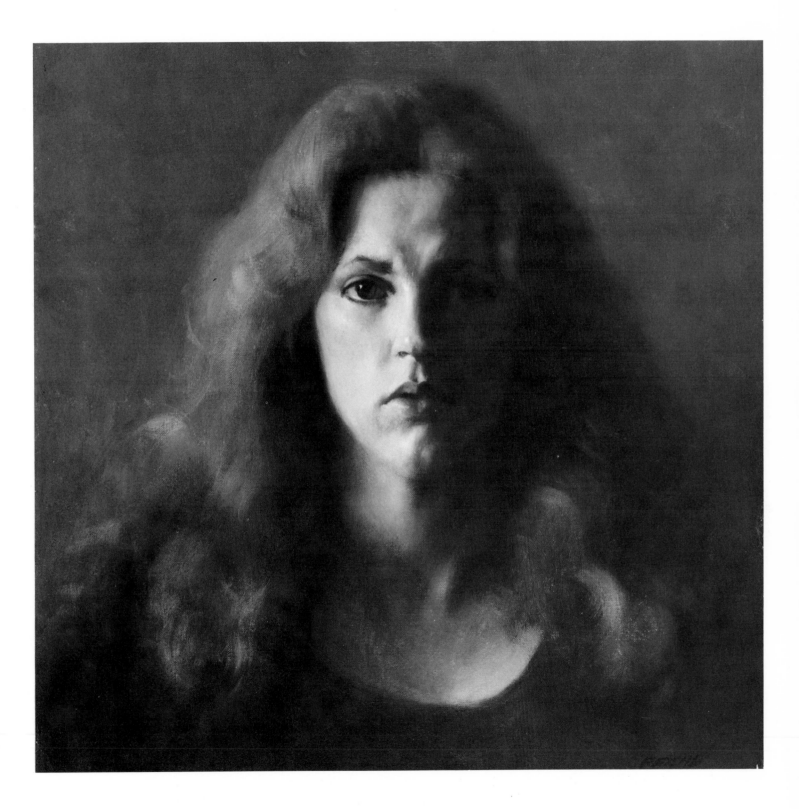

Jay. *Oil on untoned canvas, 16" x 16" (40.5 x 40.5cm), collection of Mr. and Mrs. James Mulford. Pfahl wanted to show the stress that manifested itself in the young woman's face, and particularly, in her forehead. The expression wasn't manufactured for the painting, but was a true reflection of the distress the woman was experiencing at this time. Pfahl is obviously drawn to the darker side of life, in the tradition of Goya and El Greco.*

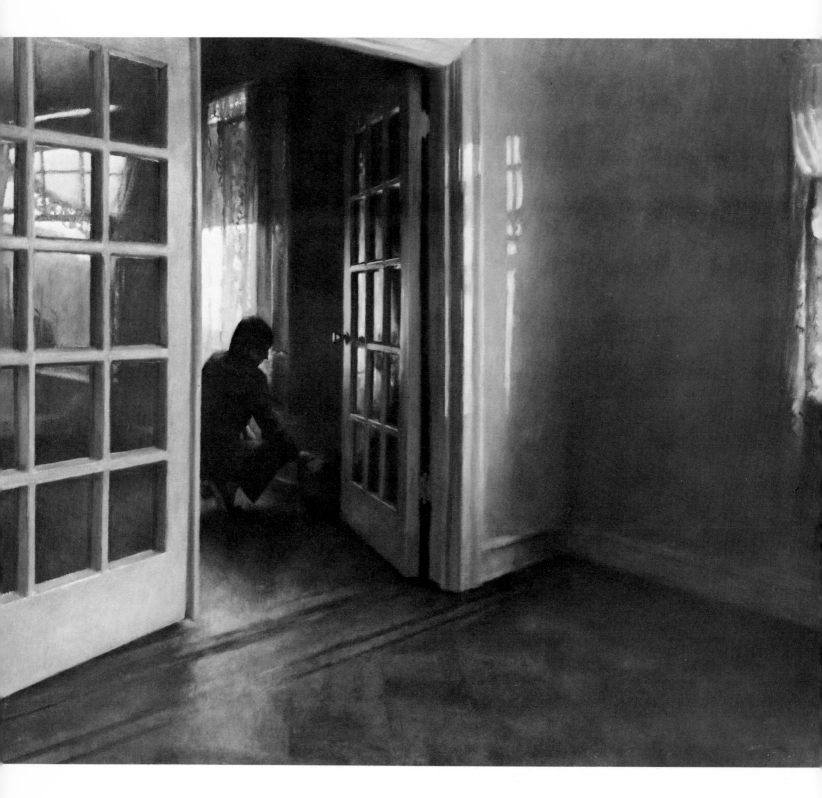

Cleaning. Oil on untoned canvas, 25'' x 30'' (63.5 x 76cm), collection of the artist. The figure here is incidental and is used merely to intensify the feeling of emptiness and silence projected by the rather sparsely furnished rooms. Pfahl is especially intrigued by the effect of light on reflections. He likes to show the same objects repeated again and again from various views and angles. These factors tend to contribute to the mood felt in dreams, where visions and images flit by, linger, and return in similar, yet somewhat altered, perspective.

ture of ivory black and Maroger medium and lets them stand for three to four days before painting.

Another product Pfahl has tried lately is a heavy board made of pressed wood chips, available in lumberyards. He primes it exactly like Masonite.

For his pastels, Pfahl uses a Canson Mi-Teintes French imported pastel paper that comes in a variety of hues.

Drawing Surfaces. For drawing, Pfahl uses good papers of various types, including smooth vellum and, occasionally, a Masonite board primed with gesso. Such a surface cannot be erased, however, and the mistakes must be excised with a razor blade. He employs Wolff's carbon pencils for much of his drawing.

Brushes. Pfahl uses filbert-shaped brushes, both in bristle and sable hair, and in various sizes. He customarily begins his paintings with the stiffer bristles and concludes with the more pliable sables, which allow for a less noticeable stroke and a glossier finish. He uses housepainter's brushes for toning his boards and canvases and for finishing his frames. He does not use knives for painting. To clean his brushes, he uses turpentine in a homemade brush cleaner with a screen on the bottom that drains off much of the excess paint.

Palette. Pfahl's palette is wooden, rectangular, and approximately 12" x 16" (30.5 x 40.5 cm). He rests it on an old captain's table when he paints. The mounds of paint around its rim rise nearly 4" (10 cm) high and the area reserved for painting is quite limited. He makes sure that this area remains clean and unadulterated by unwanted colors. From time to time, he scrapes the whole palette clean and rubs it with linseed oil to provide a smoother surface.

Easels and Furnishings. In his studio, Pfahl uses a light, easily portable, student-type easel for the smaller pictures, and a sturdy Barclay easel with ratchets and wheels for the bigger canvases. He also owns a French easel, which folds conveniently for on-location painting. His cabinet holds all the spare paints and extra equipment he needs.

If he requires a chair or other furniture for the models, he selects the desired piece from among his personal furnishings in his combination studio/ living quarters.

Pastel Box. To work in pastel, Pfahl breaks off 1" (2.5 cm) pieces which he then keeps in a box with a mesh screen on bottom which allows the fragments to sift through and fall to the bottom, leaving the sticks relatively clean and free of dust and grains.

The Medium. Prior to 1969, Pfahl used no painting medium at all. When other artists convinced him that a medium would help facilitate his brushwork, he tried various conventional media including the traditional linseed oil/turpentine combination.

Finally, John Koch advised him to test the Maroger medium, which allowed Koch certain manipulations that had eluded him before. Pfahl did so and has used the medium since.

Unlike some of the more vociferous proponents of this controversial medium, Pfahl attributes no magic qualities to it, but continues to use it because it was recommended by an artist he deeply respects and admires. He concedes that he would probably be able to achieve the same results with another medium.

The Maroger medium was the discovery of Jacques Maroger, who did extensive research into the painting methods of the Old Masters and finally came to the conclusion that their technique owed much to a medium which until then had been unknown to the modern world.

Although it varies slightly from maker to maker, the medium is basically a blend of mastic resin, linseed oil, lead oxide, and wax or turpentine, which is then cooked to a jelly-like consistency.

While its critics decry the medium as causing the paint layer to crack, yellow, and become brittle, its adherents swear to the versatility of its working qualities and its permanence.

Maroger is used as painting medium, retouch varnish, and final varnish, and those who employ it require no other solvent or medium. In a moment, we will discuss some ways in which Pfahl uses it in his painting.

Although Pfahl gets his Maroger medium ready-made from a gentleman who supplies several artists, he offers the following recipe for preparing your own medium:

1. Heat 10 ounces (295 cc) of cold-pressed linseed oil in a porcelain pot for 15 minutes, stopping just short of boiling.

2. Add ½ ounce (15 cc) of Litharge (sugar of lead). Once the lead has dissolved, remove it from the heat.

3. Add 5 ounces (148 cc) of mastic crystals. Stir with a wooden spoon until the crystals are dissolved.

4. Let cool for 15 minutes. (If the mixture is not cool, it will flame in Step 5.)

5. Add 10 ounces (295 cc) of pure gum spirits of turpentine.

6. Strain through cheesecloth or a nylon stocking.

7. Before the substance jells, put it up in tubes or jars.

8. When not in use, store the medium in the refrigerator.

Pfahl Paints in Oil

In this section, we will follow Charles Pfahl as he proceeds to execute an oil painting from start to finish.

Choosing the Surface. Pfahl takes certain factors into consideration when choosing materials for a painting. If it is to be a large picture—over 16″ x 20″ (40.5 x 51 cm)—he will more likely opt for canvas over a board. He is also aware that paint moves somewhat more easily on a canvas surface and that heavier layers of paint can be laid on canvas than on a board. Canvas is also flexible, while a board is rigid, so that the priming is more apt to crack on canvas than it would on a board.

Pfahl works on canvas that is primed with lead white, but he primes his boards with acrylic gesso which also provides a sympathetic surface.

Toning. He prefers a smooth surface for his technique. Therefore he will most likely tone his canvas with a mixture of Maroger medium and black. If he requires an even smoother surface, he will add white.

He may tone his canvas (or board) in some middle tone, which may be lighter or darker, warmer or cooler, depending on the subject. In either case, this tone will serve as the halftone value from which Pfahl will go darker for the shadows and lighter for the lights. Later, when he has blocked in all his masses and forms, he will paint over this halftone area too, but in the early stages of the painting, it will serve as his middle tone.

Placing the Shapes with Charcoal. Once the tone is dry, Pfahl uses charcoal to mark the center of the canvas with a small cross, which indicates to him the very middle of the picture. This helps him compose, since he may want the subject directly dead center, or deliberately off-center. In either case, he wants to know where the exact center is located.

Now, Pfahl places his preliminary drawings in front of him and, with the model in place, he begins to draw in the head and the basic shapes and dimensions of the figure with charcoal. There is no attempt at precise drawing, merely an effort to place all the elements in their proper location.

When the job is completed, Pfahl lightly wipes away the charcoal, leaving only enough to serve as a guideline.

Constructing with the Brush. Now, Pfahl turns to paint and, mixing a neutral shade of, say, raw sienna and blue, or some similar shade that will not interfere with the subsequent layers, he begins to construct the painting with more care and precision. He uses very little paint, almost a drybrush technique, and puts in all the elements, so that every aspect of the painting is laid in fairly carefully.

Laying In the Entire Canvas. This stage is executed with all possible speed.

First, Pfahl thins his paint down to almost liquid form by the addition of the Maroger medium. He then proceeds to lay in all the tones so that every inch of the canvas is covered. He's anxious to form a layer of paint over which he can proceed with the actual painting.

Starting with all the darks, he attempts to put them down in their proper color and value, knowing full well that they will lighten up considerably upon drying since as yet he is working only with transparent washes and the white untoned canvas will shine through. He then proceeds to place his halftones and lights. Even though the paint is relatively liquid, Pfahl tries for as much accuracy of shape, tone, and color as he can achieve. This stage can be compared to the color impact sketch as described in previous sections.

Reestablishing the Elements. In this stage, Pfahl goes back into all the darks, trying to bring them down to their true value—that is, darken them. This process is somewhat easier now that there is a layer of paint underneath, since it is always easier to lay paint over paint than over a raw surface. The same thing is then done with the halftones and lights.

Basically, this step represents a reaffirmation of the previous stage, an attempt to fix all the colors and values onto the surface so that Pfahl can determine how the basic values and colors will appear in the final painting. It is at this stage that Pfahl decides whether to go on or to discontinue the painting, and he wants his options present in visual form in front of him before he makes the final commitment to go on.

Commencing to Paint. Until now, Pfahl has been preparing the picture. It is only now that he begins the actual process of *painting.* He now switches from bristle to sable brushes, which he will employ until the end. From now on, he will not move the paint around. Instead, he will place a stroke, leave it there, and place new strokes over it.

He now goes back into his darks once again and paints them with all the accuracy and fidelity each individual painting requires. Ideally, they should be finished when he is through and not require any additional work. He proceeds to do the same with the halftones and the lights.

Throughout this stage, Pfahl strives to refine all the elements—the drawing, the colors, and the values—and to make sure that everything is accurate.

In this quest, Pfahl spends much more time at his palette than on the canvas. Each time he looks at the subject, he sees new colors. So each time he is about to place a new stroke, he prepares a new mixture with extreme care and deliberation. This for him is a most precise operation, since he conceives of painting as being the correction and elimination of mistakes, as well as the gradual buildup of paint and refinement of all the elements in the painting. When this correction and refinement has been done to his satisfaction, the painting is finished.

Thus, Pfahl generally would not mix up a big batch of color that he would apply again and again. Instead, each stroke represents a new mixture, a new

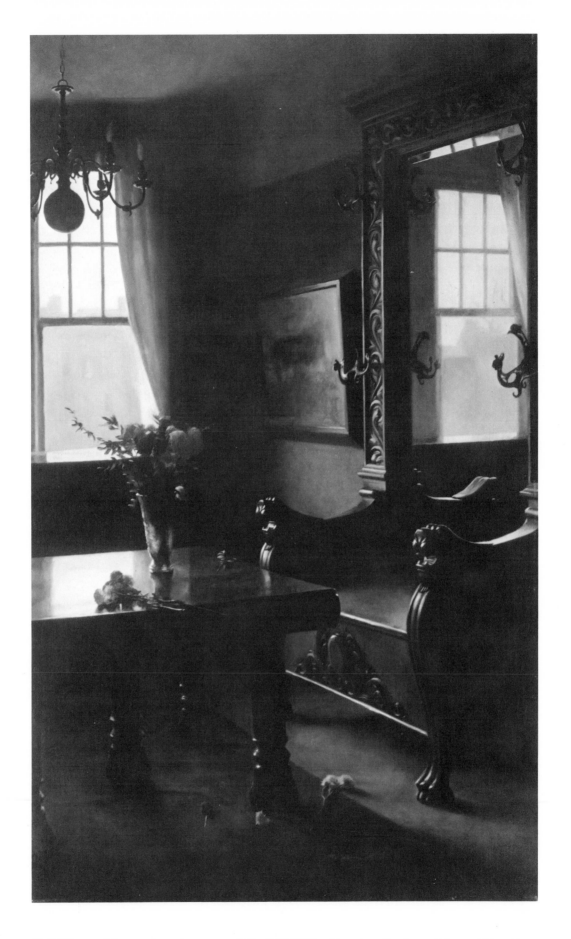

Hall Mirror. *Oil on untoned canvas, 48'' x 24'' (122 x 61cm), collection of Mr. and Mrs. Hummel. An interior without figure is a subject to which Pfahl returns periodically in his continual probe of the elements within his studio. Many of these objects reappear again and again in his paintings, since nearly all his pictures are painted within this fixed environment. Yet, each time Pfahl sees something new and different in these familiar pieces, he is challenged anew to reveal yet another aspect of a subject of which he never seems to tire.*

effort to correct something that is not quite right, or an attempt to add additional nuances of color to the lay-in.

He applies the paint in small, thin applications. This is partly due to the nature of the Maroger medium, as well as to the sable brushes which can only transport small amounts of paint at a time.

Pfahl's tendency is to apply thicker, opaque paint in the light areas and thinner, transparent paint in the shadows. Some of the darks may, in fact, require little paint since they may be represented by the tone of the canvas. Also, Pfahl's color in the shadows tends to be more even, not broken as would be his color in the lights. He describes his method as "painting in broken color with very subtle transitions of hue."

Using the Maroger Medium. If Pfahl decides to paint into a wet surface rather than a dry one, he will apply a small quantity of the Maroger medium to the area and wipe off the excess so that enough medium remains to allow him to paint "into the soup," as the old painters used to call it.

Actually, once the preliminary steps have been completed and the actual painting stage begins, Pfahl tends to use the medium sparingly, if at all. Actually, his tendency is to use the medium less and less as time goes on.

Glazing. Occasionally, Pfahl wants to bring down a tone of a passage that seems too high in value. He will then generally use a quantity of the Maroger medium, adding a small amount of ivory black until it turns liquid. He will then brush on this transparent mixture over the area in question.

He may also prepare an occasional *color* glaze by mixing medium with the desired shade, brushing it on to alter the hue of some area in the painting. Pfahl finds that six small jars of the medium are sufficient for a year's work. He stores it in the refrigerator when he is not using it.

One quality of the Maroger medium is that it sharply accelerates the drying time of paint. Pfahl is satisfied with the medium's general performance, but he is convinced that it should be used sparingly. Since he uses it for painting, glazing, and varnishing, he does not need to acquire other mediums or to mix mediums, a factor Pfahl considers an advantage.

Finishing the Painting. The final stages of painting may involve certain adjustments and refinements, such as placing the lightest highlight or adding a detail here or there.

These days, Pfahl finds himself painting more loosely than ever and getting further away from any tendency toward gloss or fussiness. He is learning to achieve the semblance of detail with just a few tones, possibly utilizing the tone of the canvas to achieve that illusion of precise reality for which his work is known. Also, he is more apt these days to reach instinctively for the right color than he might have before, and to stop painting sooner than he would have in the past.

About two months after the painting is finished, Pfahl gives it a final varnish with a light coat of Maroger medium.

Pfahl Draws with Pastel

At present, Pfahl uses pastel mainly as a preliminary step for his oil painting, seldom as a medium in itself. Although he insists that he only draws in pastel, the fact is that Pfahl uses pastel in a masterful fashion, whether the procedure is classified as drawing or painting.

Pfahl finds working in pastel a very time-consuming process. He works with all the 500 sticks of his assortment laid out in front of him, and the process entails searching for precisely the right shade for each stroke. Pfahl finds the attainment of really dark darks one of the major drawbacks of pastel.

The Surface. Pfahl works on Canson Mi-Teintes paper, which comes in over 30 shades. Because the tone plays such a vital role in his pastel drawing, he selects the shade most appropriate in color and value to the subject.

The Technique. Pfahl breaks off a 1″ long (2.5 cm) piece of the desired stick and uses either its tip or side to place the strokes. He lays stroke after stroke either next to or over the previous strokes. He might be said to work essentially in line rather than in tone, building up a thin layer of color through cross-hatching or juxtaposition, never through blending or fusing.

Pfahl is most apt to use pastel for figure work. Often he will concentrate on just part of the figure, leaving the rest vague or completely unfinished. His strokes never consciously follow the form. He does little or no erasing and uses no fixative. Occasionally he will flick off some of the loose particles of color or use a chamois to wipe an area clear.

Pfahl's assortment of Henri Roche sticks is expensive and difficult to obtain in this country. They are firmer in texture than the usual soft pastels to which Americans are accustomed and contain fewer harsher colors than the local brands.

Framing the Picture

Pfahl does all his own framing. His preference is for a rather simple frame, but he might consider a more ornate molding for a painting with intricate patterns. He used to build his frames from scratch, but these days, he selects the raw molding readymade and has it assembled by the framer. However, he still finishes his frames himself.

Finishing the Frame. Pfahl's procedure for finishing the constructed frame is as follows:

1. Apply approximately three coats of acrylic or homemade gesso.

2. Sandpaper between applications of gesso.

3. Prepare rabbitskin glue. (You can buy this in slabs or crystals; slabs are better.) Soften one slab of glue by soaking in 24 ounces (709 cc) of water overnight. To liquify, place the softened glue in a double boiler and heat until it turns to liquid. The double boiler prevents the glue from boiling. This mixture can be stored in a refrigerator almost indefinitely. If left out of the refrigerator, it eventually turns rank.

4. Add nine parts of water to one part of the liquified glue and heat. Now take some of the glue/water mixture and blend with an equal amount of gilder's clay. (Gilder's clay is a substance used to provide a foundation for gold or metal leaf. It comes in liquid form in a jar and in red or yellow. Pfahl prefers the red.)

5. Now brush on three coats of this glue/water/gilder's clay mixture to the frame, smoothing out any lumps that may form with your fingers.

6. After it dries, polish the finish with a soft rag to smooth the surface even further and to darken the red tone.

7. The next step is to apply the gold or metal leaf. Pfahl prefers the metal leaf, which is approximately 1/5 the cost of the gold. Metal leaf comes without the backing that gold leaf possesses and is much easier to handle. It is also naturally brighter than gold leaf and requires no additional burnishing as does gold leaf. (Gold leaf is burnished with an agate burnisher.)

8. Mix ¾ of a quart of water (0.71 liters) and one teaspoon of rabbitskin glue and heat it in the double boiler. Then take 1/5 of a quart (0.19 liters) of alcohol and pour it into the glue/water mixture and heat it.

9. Brush this glue/water/alcohol mixture over the areas where you intend to apply the leaf, and lay the leaf into this wet foundation. Using a tissue, smooth the leaf down.

10. When the surface is completely dry, take a dry cloth and wipe away any excess leaf that may have accumulated.

11. If you want to antique or distress the frame, use a hammer or any other instrument to knock the appropriate bumps, nicks, or notches into the frame.

12. Wipe once more with a cloth to get rid of any particles of wood, clay, or gold that may have formed as a result of the knocking around.

13. Take dry powdered oil pigments such as raw sienna, burnt umber, raw umber, black, white, or maybe a few stronger hues such as blue, green, or red, which are to be used sparingly due to their powerful coloring action. Liquify these colors with a mixture of alcohol and shellac.

14. Now, depending upon how much of the gold you want to show through the finish, stipple the paint on with a paintbrush or a toothbrush. Or lay a transparent wash over the entire frame and then stipple over it.

15. When this is dry, apply bowling alley wax or Butcher's wax and rub it over the entire frame.

16. Let it stand a while, then buff to the desired gloss. By rubbing harder in selected places, you can have some of the underlying red tone come through. Should you prefer a dull finish to a glossy one, rub it with rottenstone to dull the tones of the frame and add to its antique effect. (Rottenstone is a gray powdered stone that will settle into crevices like dust and cling to even the most minute cracks.)

If you should wish, you can go through the entire procedure (Steps 1 to 6) and omit the metal or gold leaf. However, Pfahl advises applying the gilder's clay regardless of whether or not any gilding is to be done, since this would serve to protect the surface from chipping and serve as a base for the paint that would be used for the finish.

Demonstrations

Afternoon Rest *(studies). Pencil on paper, 11″ x 14″ (28 x 35.5cm), collection of the artist. These are two preliminary studies for the oil painting that follows. The upper one is merely a rough sketch to indicate the general placement of elements. In the lower, Pfahl goes a step further and works out some of the values to obtain a preview of the picture's tonal relationships. Note how little he will vary from these sketches in the final painting. Obviously he is fairly well satisfied with the way the concept appears in pictorial terms and feels confident to proceed further.*

Step 1. Working from his sketches, Pfahl quickly draws in the figure for placement on the silver-gray toned Masonite board. Although in the original concept he had left the legs uncovered, he finally decides that it would be better to cover most of them under the blanket. Pfahl makes most of these decisions prior to proceeding to the canvas or board. Other artists change their paintings considerably as they go along, but this is contrary to Pfahl's basic approach.

Demonstration One: A Female Nude

Step 2. The primary effort here is to resolve the basic value before proceeding further. Pfahl reinforces the drawing and lays in some of the darker darks in the hair, the crotch, and the wall in the upper-left-hand side of the painting. Some major folds in the blanket are blocked in and the patterns in the blanket are more accurately indicated. It is now time to begin placing basic colors.

Step 3. Pfahl roughly covers the entire board with a hue that approximates the actual colors. The basic areas of the patterns in the blanket are laid in. The light areas in the right forearm and breast are indicated. Pfahl now can visualize how the finished painting will emerge. It is at this stage that he decides whether or not to go further. If the elements do not appear right at this stage, he will either abandon the painting or restructure his concept.

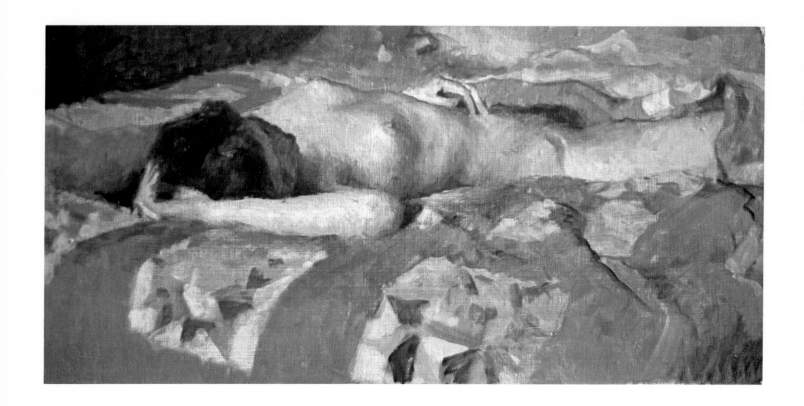

Step 4. Here, Pfahl blocks in all the basic tones in the painting with the exact color, exploiting the tone of the board as much as possible and pulling together the darks and the lights to provide some feeling of unified form. He also lays in the quilt as quickly as possible, indicating the design of the pattern and trying to be as accurate as possible as to true colors, values, and shapes. The face is still represented as a single medium tone and not yet accented by those lights that will give it identity and shape.

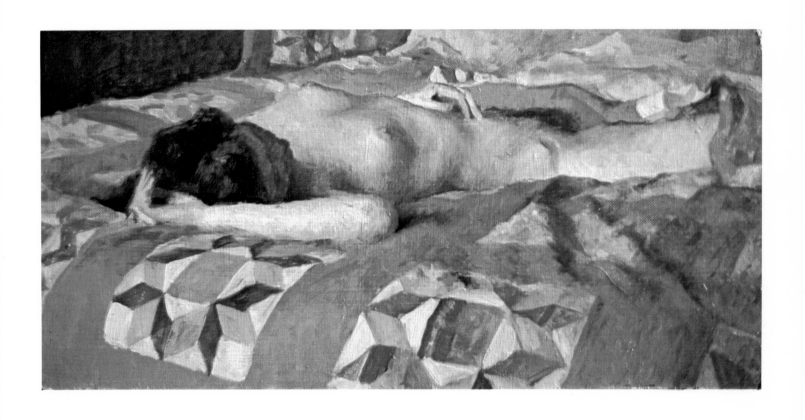

Step 5. Pfahl deepens all the darks again to reestablish their true value since the paint in the previous steps is not yet sufficiently built up to show them in their actual depth. He then turns to the quilt, working out some of the basic shapes of the folds as well as the designs in the quilt pattern, putting them down as flat areas of basic color without indicating any of the overlying textures. He is more concerned with getting their correct dimensions than their exact hue, especially the two large main squares in the foreground.

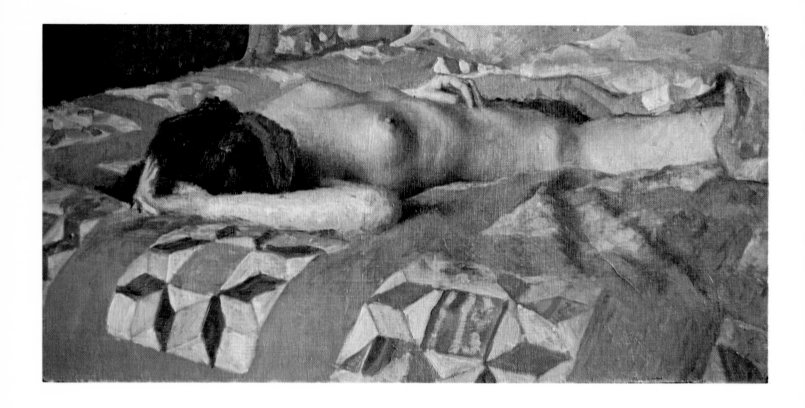

Step 6. Again Pfahl goes back to the patterns in the quilt, seeking to refine and redefine their broad basic shapes. He then turns to the chest and abdomen area of the figure and places the many cool grays and blues he finds there. Much of this area was established, not with additional paint, but by manipulating the actual gray tone of the surface. This is one reason Pfahl tones his surfaces—in order to exploit their value and color so that they represent halftone areas in the finished painting. Since he lays his paint in thinly, this device serves his technique admirably. He goes somewhat cooler all over the painting.

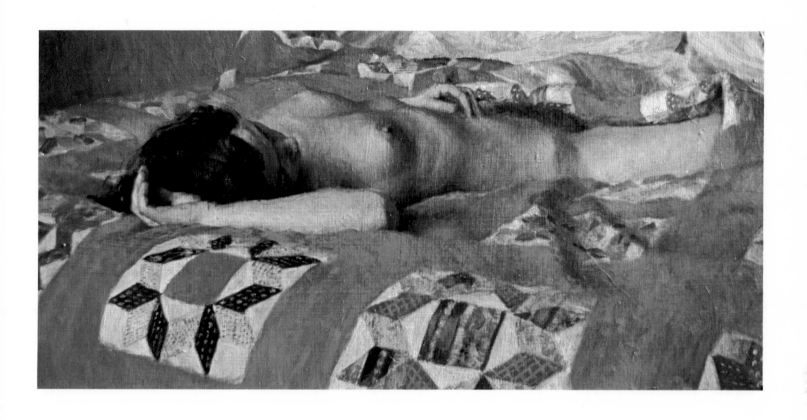

Step 7. Pfahl again concentrates on the patterns in the foreground areas of the quilt and now lays in the paint with attention to the accurate detail and color of the designs within these patterns. He adds stronger color to the painting and warms it considerably throughout. He corrects the chartreuse hue of the quilt and brings up the warmer quality it actually presents. By now, most of the square patterns in the quilt are fairly accurately worked out. The entire head and the forearm are repainted. The head is kept simple to foster the illusion of its blending with the shadow of the body.

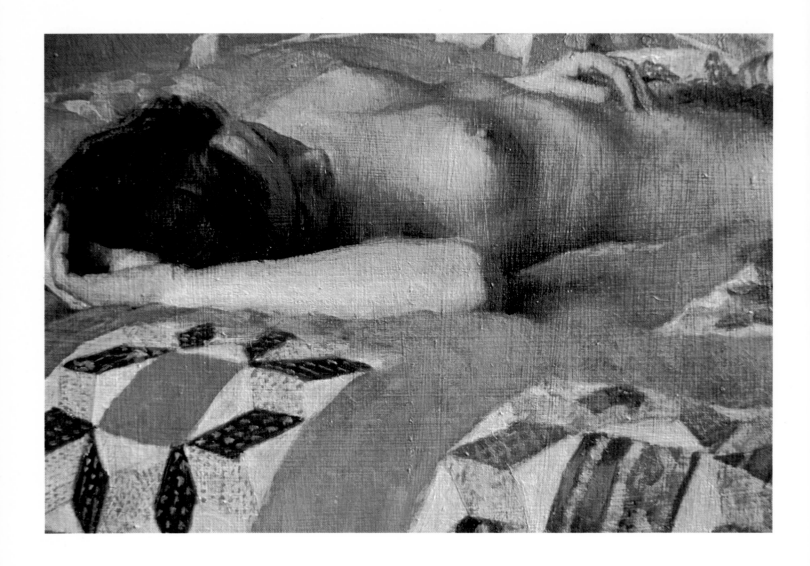

Step 7 (detail). This closeup view shows how Pfahl employs an almost pointillist technique to depict the design of the patterned squares in the quilt. Seen from some distance, the little spots of blue and red color seem to vibrate and provide the illusion of texture in the design. Actually, the drawing is loose, the color is simple, and no tight edges exist; but the general effect successfully conveys the impression of a busy, variegated pattern.

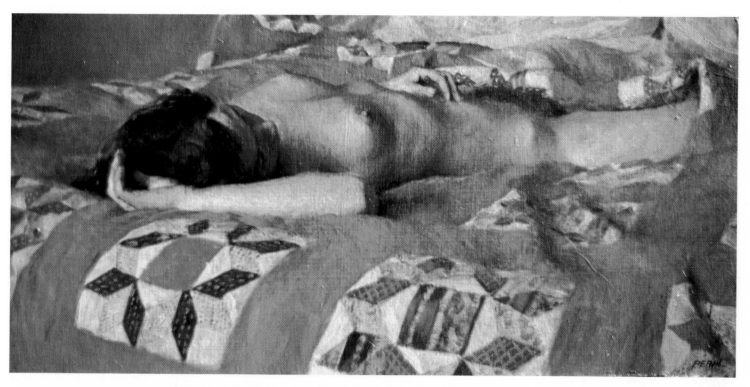

AFTERNOON REST. Oil on toned board, 7½″ x 16″ (19 x 40.5 cm), collection of the artist.

Step 8. Pfahl lightens and warms up the upper left corner of the painting which, till now, has been a dark, indeterminate space. He goes back into the forearm and the model's right breast and lightens both areas. He finishes the right leg, which represents the second lightest area in the painting. He keeps it lighter in value than the rest of the torso but darker than the lightest area, the forearm. He carefully repaints the left hand that is resting on the abdomen. In the lower right-hand corner, he places a fold through the partly visible square to break up the pattern, and lightens it to keep it from being too distracting.

Step 8 (detail). Note the small light accents on the tip of the nose and the forehead. These highlights now serve to give form and shape to the face, which remains basically a medium-dark tone. A cool bluish light serves to bring the right breast forward. The edges are extremely soft throughout the body as befits the true character of flesh, yet we receive a distinct impression of receding planes as the figure moves away from its most forward point—the forearm.

Reclining Figure *(study). Pencil on paper, 14'' x 11'' (35.5 x 28cm), collection of the artist. Pfahl works out in line the general pose of the figure. He tones in the areas around its contours to study the double X design produced by the pose. By darkening the negative shapes, he gets a clear indication of the shape of the positive form. This sketch is done merely for the sake of composition. There is as yet no concern with actual drawing of the figure and dress.*

Demonstration Two: A Clothed Female Figure

Reclining Figure *(study). Pencil on paper, 14" x 11" (35.5 x 28cm), collection of the artist. Now Pfahl executes a fairly detailed tonal study that shows where all the darks, halftones, and lights occur in the figure. The folds of the voluminous dress are placed with care, and details of the pose settled. Ostensibly, Pfahl could use this sketch to paint the picture without further use of the model, but he relies on the live subject to provide him with those nuances of color that are such an important part of his approach.*

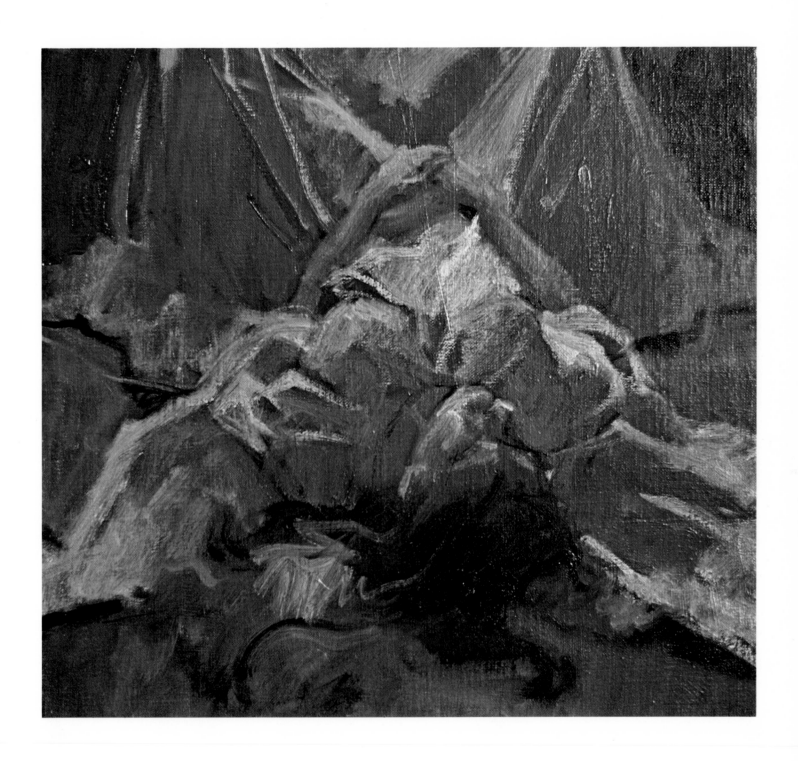

Step 1. Pfahl draws a center line down the canvas to establish the two main angles that dominate the pose. The first is the large X formed by the legs and arms meeting at the figure's crotch. The second, is the X formed by the sleeves and the angles of the dress against the rug. Pfahl then places the vortex of the larger X exactly on the vertical center line, but deliberately moves the head off-center to the right. He quickly places the darks of the head and lays in the lights of the dress quickly and broadly. The canvas had been toned a dark bluish gray and it now serves as the initial overall medium tone, but with a small addition of yellow ochre.

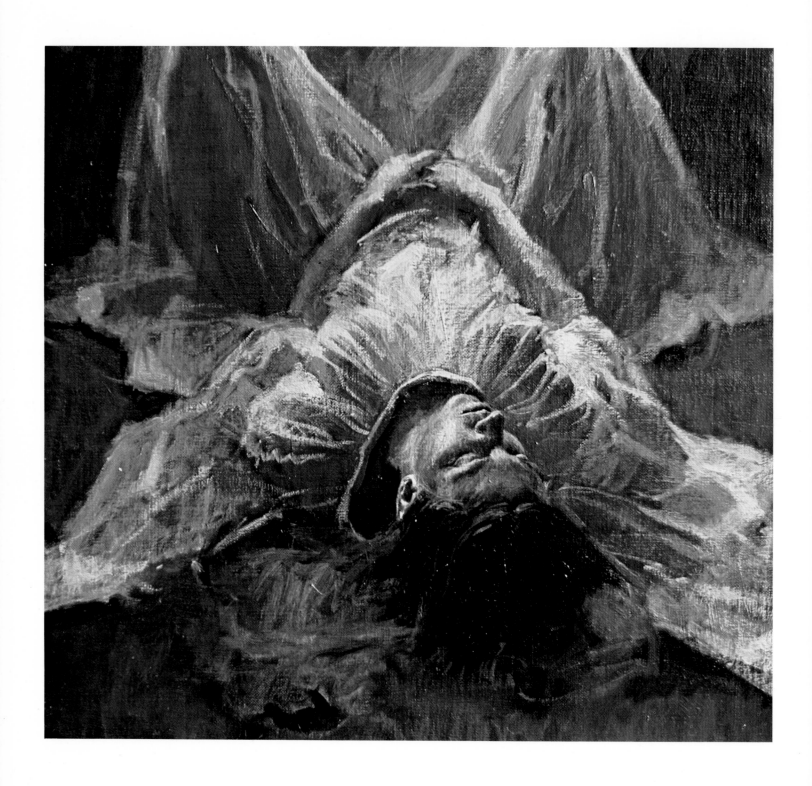

Step 2. In this step, the head is carried almost to its finished stage. Since there is not yet enough of a foundation of paint for the colors to set exactly, Pfahl reestablishes the darks and some of the lights to bring them up to their proper value. Pfahl now lays in the basic blue tone of the carpet to better delineate the negative shapes of the dress on the floor. He quickly establishes the effect created by the dress as it stretches across the model's chest, then swiftly indicates some of the smaller folds and wrinkles caused by this action.

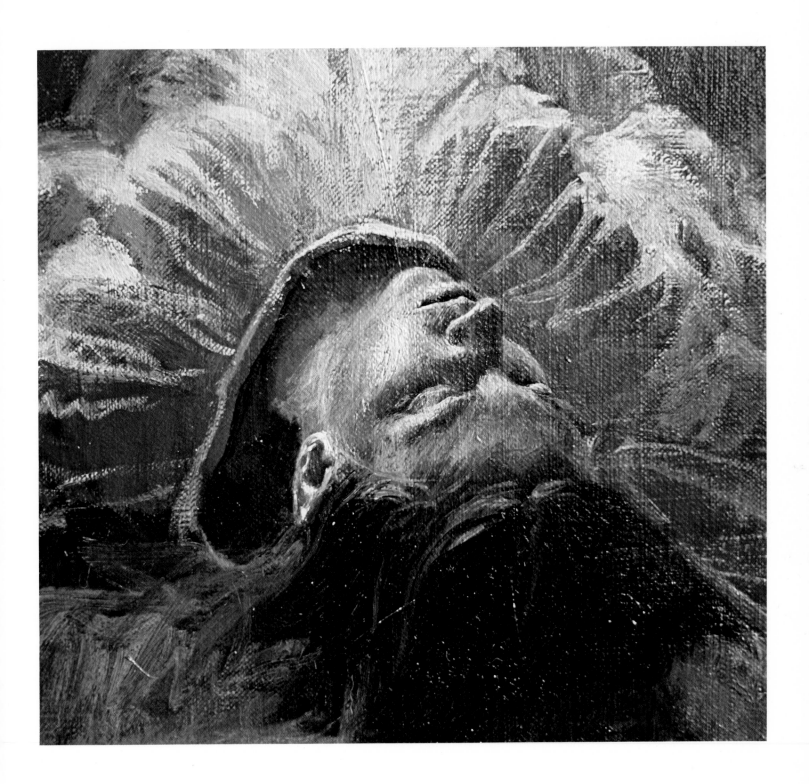

Step 2 (detail). Here you can see how Pfahl has taken full advantage of his toned canvas to show the myriad pleats and creases formed by the cotton material. By concentrating on the lights only, he has managed to create the illusion of soft, crinkly material without painting in any halftone accents. Note how effectively the head is painted in a series of soft, open planes. Pfahl is a master of illusion in that while his paintings appear sharp and detailed, they are actually very loose and open in technique.

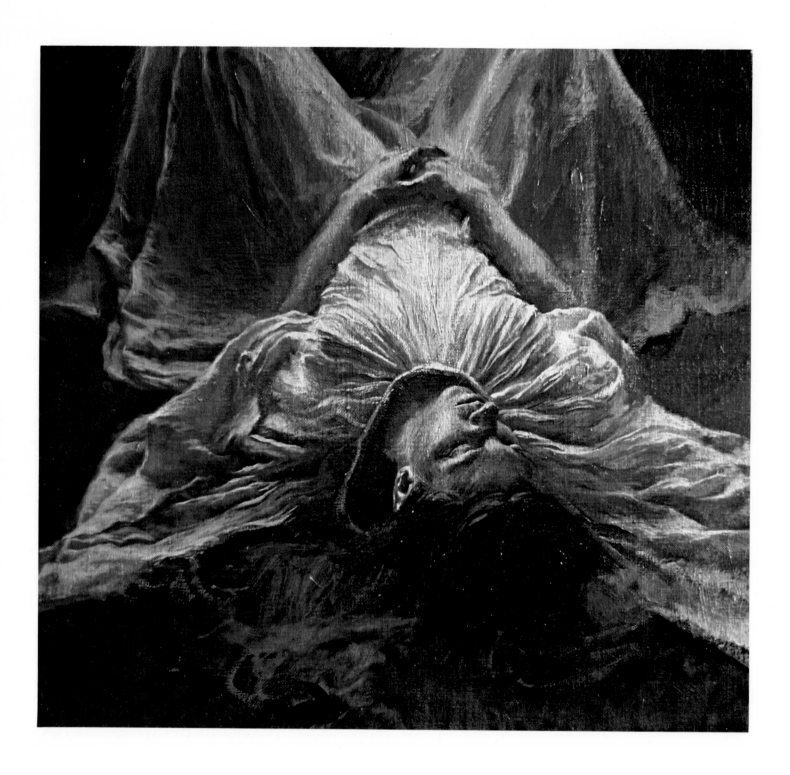

Step 3. In this step, Pfahl begins to paint the dress, paying greater attention to the actual shape of the folds and wrinkles. He does this by painting in sections. He asks the model to lie still, then completes one area of the dress before moving on to another. This is eminently more practical than seeking to depict all the breaks in the cloth throughout the subject, since each time she would resume the pose these folds would be different. By doing a section at a time, Pfahl spares his model and follows a logical approach to such an intricate undertaking.

Step 3 (detail). This is a closeup view of one of those areas that Pfahl has completed. Except for a few yellow ochre accents here and there in the dress, it is basically a combination of blue-gray halftones and white lights. Although Pfahl has painted in some of these halftones, many of them are still part of the tone of the canvas. Had the darks in the dress gone deeper, the effect of the light, fluffy material would have been completely destroyed. Pfahl knows how to orchestrate his values for maximum effect.

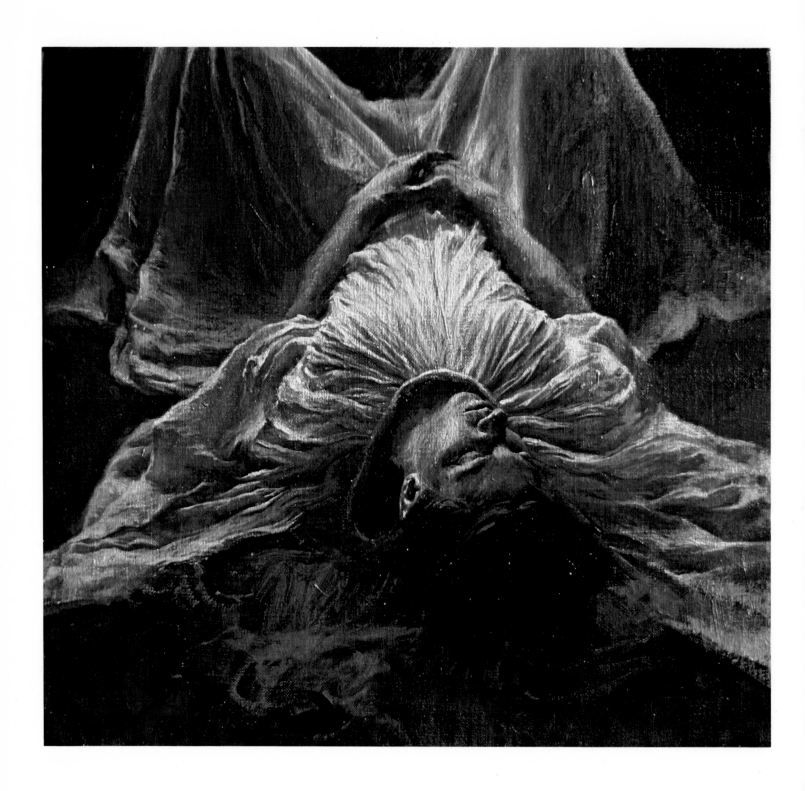

Step 4. Now, Pfahl turns his attention to the upper part of the dress and carries it as far as he can before the model can get up and rearrange the breaks in the cloth. First he does one leg, then the other. He pays further attention to the hands and the drawing of the arms, trying to keep the tones there relatively subdued. Now Pfahl very lightly indicates some of the patterns in the carpet. At this point, the figure and the dress are basically finished; most of the additional work remains in other areas.

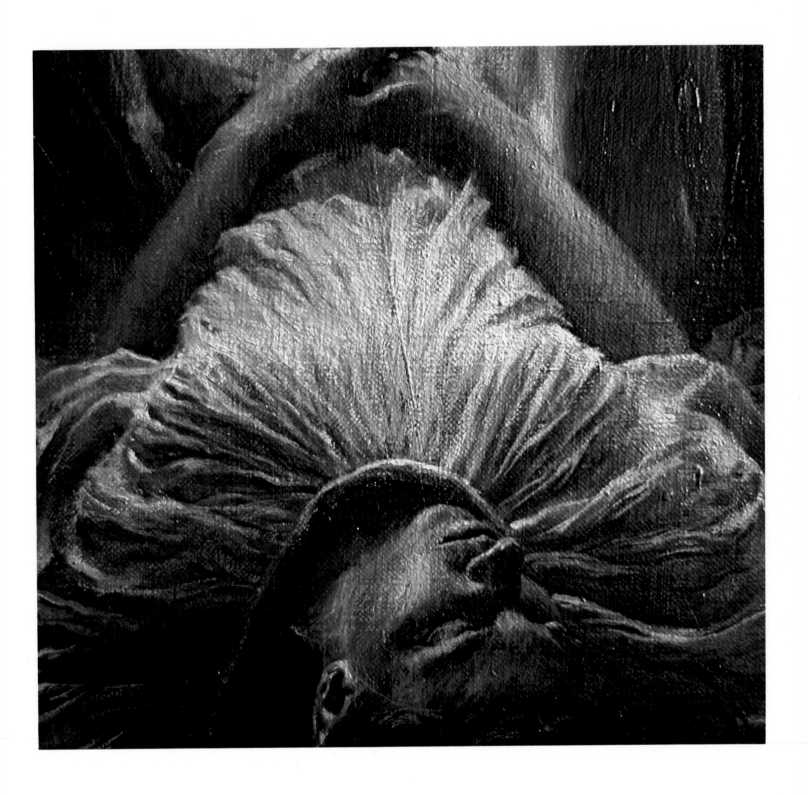

Step 4 (detail). In this closeup view, note how Pfahl has subdued the light on the arms to focus in on the white of the dress, which dominates the painting. Had the flesh been painted too light, much of the impact of the intricate material would be lost. Although the body is fully covered in this pose, the clinging cloth gives a clear indication of the body's main thrusts and directions. The pose emerges as unusual because of the angle from which Pfahl elected to paint it.

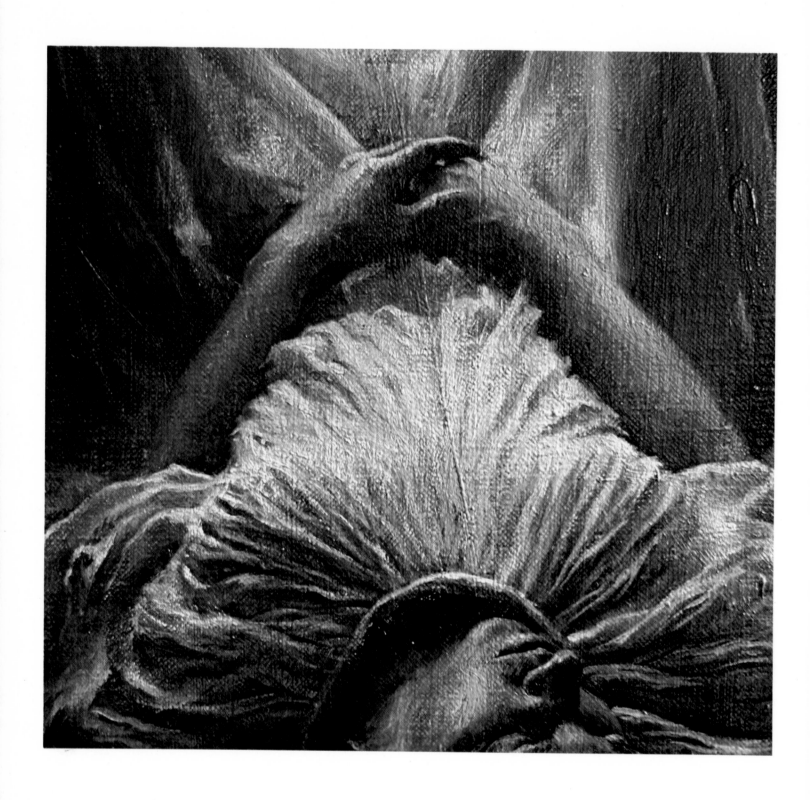

Step 4 (detail). Again Pfahl demonstrates his skill at portraying values. The subtle gradations of light, halftone, and shadow interplay with such harmony that no jarring note exists anywhere and all elements seem to blend gracefully and naturally into each other. Pfahl does not employ tricky highlights or reflected lights to achieve his ends. It is the gradual turning of forms that captivates the viewer's eye and lends the effect of startling reality to flesh and cloth. Pfahl's paintings bring to mind images seen in the reflections of a mirror. They are true, yet veiled in an aura of mystery.

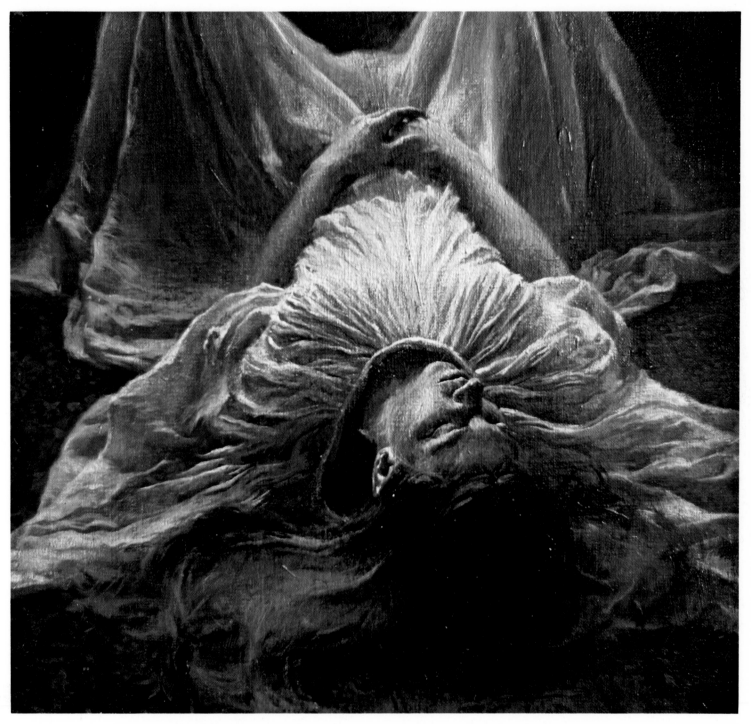

RECLINING FIGURE. Oil on toned canvas, 12″ x 12″ (30.5 x 30.5 cm), collection of the artist.

Step 5. In this concluding stage, Pfahl glazes down some elements in the sides of the dress to create the feeling of the material fusing with the darks of the floor. He completes the patterns in the carpet and reestablishes some of the lightest lights in the chest and abdomen. The soft treatment of the hair is particularly attractive as it weaves in and out of the texture of the carpet. There is barely a harsh edge anywhere in the painting, yet to an untrained eye it would appear that Pfahl took months to paint so much detail. Actually, it was completed in a matter of days.

Step 1. Pfahl first marks the center of a dark blue-green toned canvas with a cross. He then roughly establishes in charcoal the placement of the figure, the couch, and the rug. Because of the almost vertical edge of the left side of the carpet, Pfahl attaches an extra piece of cardboard above his easel so that he can establish a vanishing point from which to measure the unusual perspective of this line. The problem comes about because from where he stands, Pfahl has to look simultaneously straight down onto the carpet and up at the figure, a situation that makes it extremely hard to achieve correct perspective.

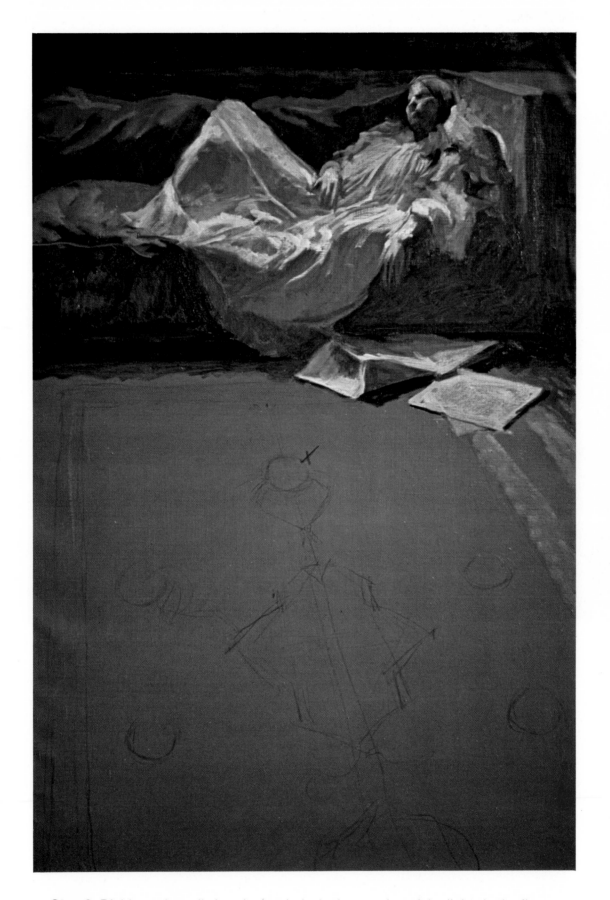

Step 2. Pfahl now broadly lays in the darks in the couch and the lights in the figure, using the tone of the figure to serve as most of the halftones and shadows in the dress. An important area of light is the newspaper that the model has dropped to the floor as she apparently dozed off. The paper has to look just so—as if it were inadvertently dropped, not deliberately arranged. In addition, although similar in value to the lights in the dress, the paper should not draw too much attention away from it. Pfahl has to select his areas of interest carefully.

Demonstration Three: A Figure in an Interior

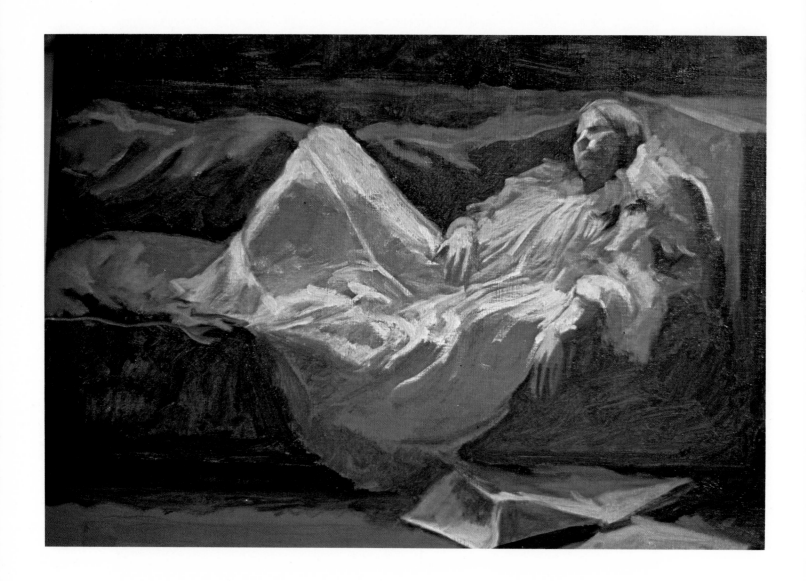

Step 2 (detail). This closeup shows how extensively Pfahl has employed the tone of the canvas to indicate the light patterns in the painting. Except for a few touches of warm color in the face, hands, and hair, all the forms have been picked out with whites in the figure and some darks in the couch. So effective is this method of working that Pfahl might have stopped right here and come up with an adequate study of a dozing woman.

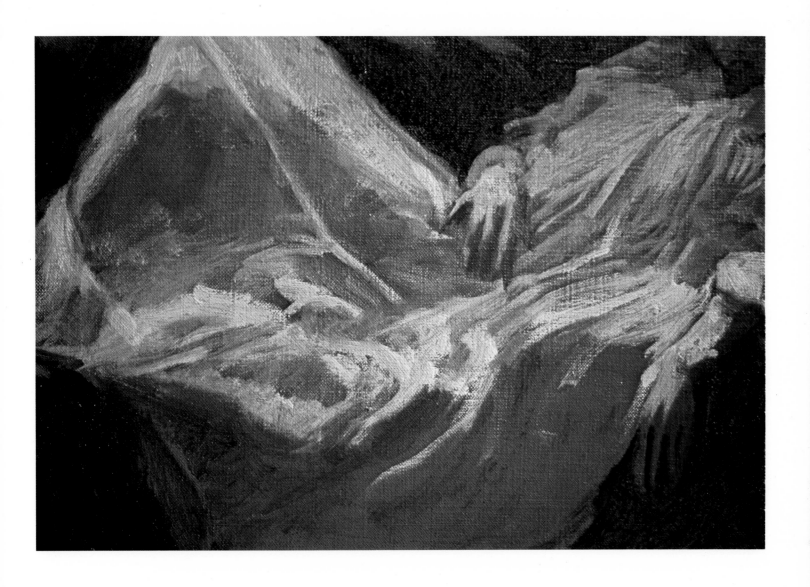

Step 2 (detail). An even closer look reveals how naturally the folds of material follow the underlying forms of the reclining figure. A competent painter always puts down the major shapes and saves the details and works on the smaller forms for later. Notice how quickly Pfahl captures the essentials of the pose—the degree of finish he now elects to add to the illusion are a matter of personal choice. Pfahl's work is becoming increasingly more simplified as he matures as a painter.

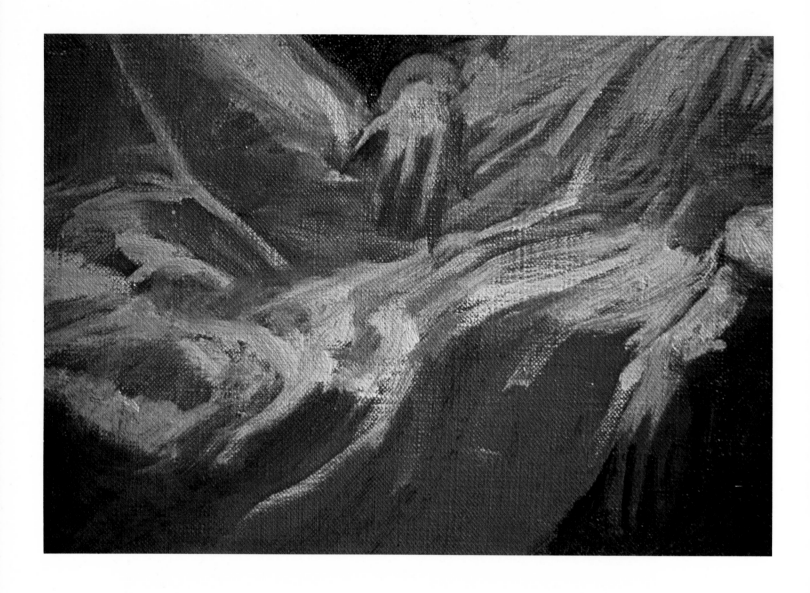

Step 2 (detail). The model's right hand, painted in few strokes, is already correct in proportion as well as color. Subsequently, Pfahl will move the little finger closer to the others, but the general action is already established. Had Pfahl not made preliminary sketches and studies, he might have been forced to make these decisions now, during the actual painting of the picture. But careful planning helps Pfahl resolve many problems beforehand and frees him to concentrate on the problems of color.

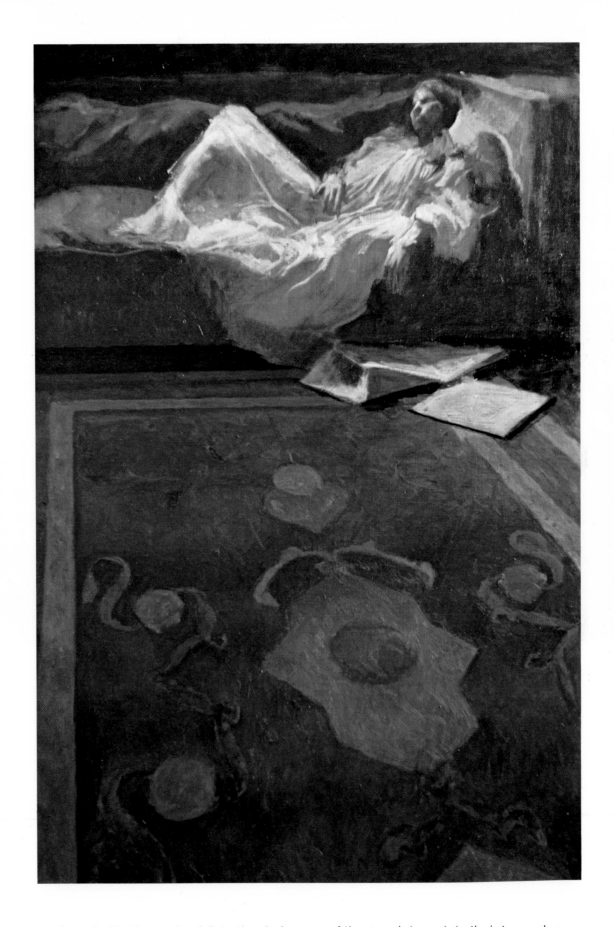

Step 3. Pfahl goes back into the dark areas of the couch to restate their true value. Then he confines his attention to the carpet. First Pfahl lays in the main elements within the carpet. Then he checks them with string plumblines against the vanishing point on the cardboard of his easel to make sure all the proportions and relationships are correct. Once satisfied that these factors are fairly accurate, Pfahl proceeds to paint in the deep blue background of the carpet, and then adds the yellow ochre and lighter blue patterns within it.

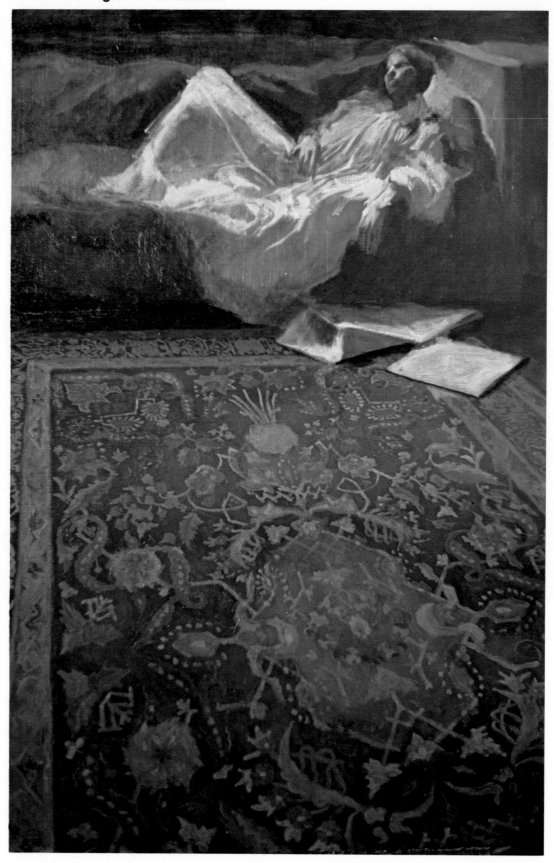

Step 4. His foundation fairly secure, Pfahl now paints the varying intensity of the cool, neutral light. This light, which barely reaches the foreground, grows increasingly intense as it nears the window above the sofa (which does not appear in the painting). He paints the areas of carpet closest to him a darker, more vivid blue where the light is lowest. Then, as the color of the light grows stronger, he gradually adds more of its cold, gray tone to the color of the carpet as he moves toward the sofa, where the light falls with maximum intensity.

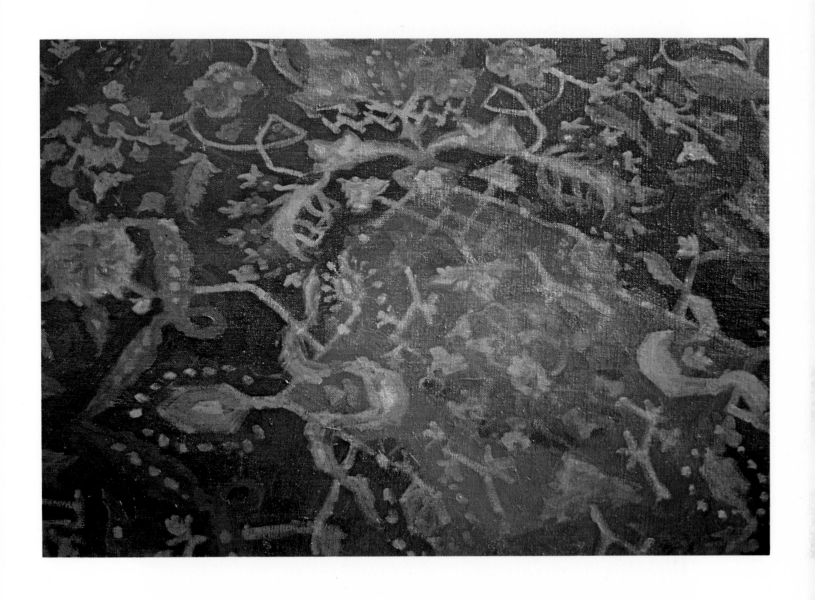

Step 4 (detail). In painting the intricate design of the carpet, Pfahl demonstrates his uncanny ability to paint detail with a minimum of fuss and effort. A person of lesser skills might have thrown up his hands at such a seemingly difficult challenge, but Pfahl makes the carpet realistic simply by placing all the elements where they belong and in their appropriate shapes and values, with no hard edges.

Step 4 (detail). An even closer look reveals how loosely and simply the patterns are painted. Since the human eye cannot focus on more than one place at a time, the wise artist knows that it is futile to carry every section of canvas to a high degree of finish. It is the *illusion* of such finish that convinces the eye that the same amount of detail is present all over.

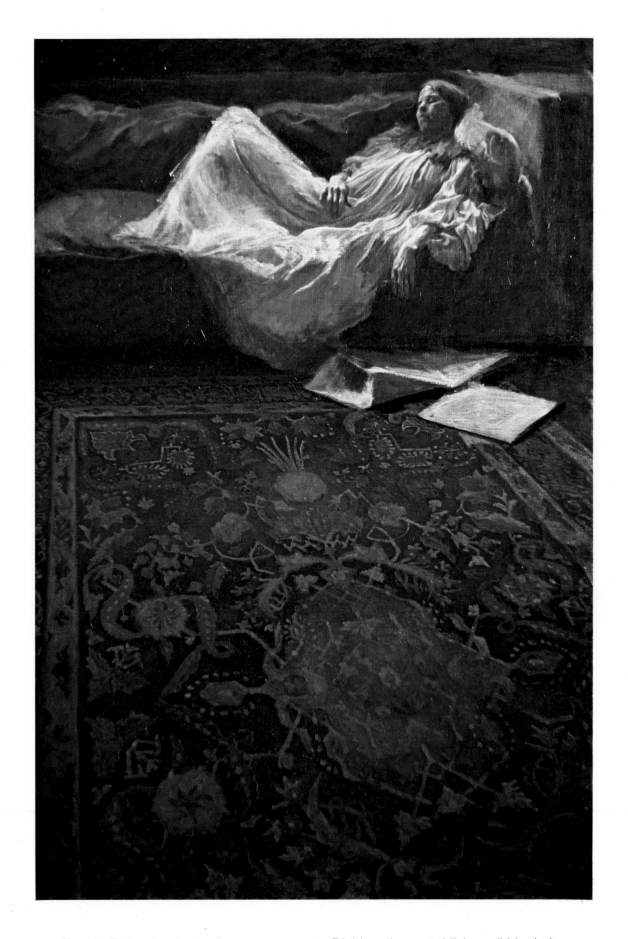

Step 5. Returning to the figure once more, Pfahl again reestablishes all his darks, beginning with those on the head. He then paints the entire upper body, setting the position of the hands and establishing the folds of the material. Again, Pfahl works in sections, finishing one area of the dress before moving on to another area. Only in this way can the character of the clingy material be established without extensive remodeling each time the model resumes her pose.

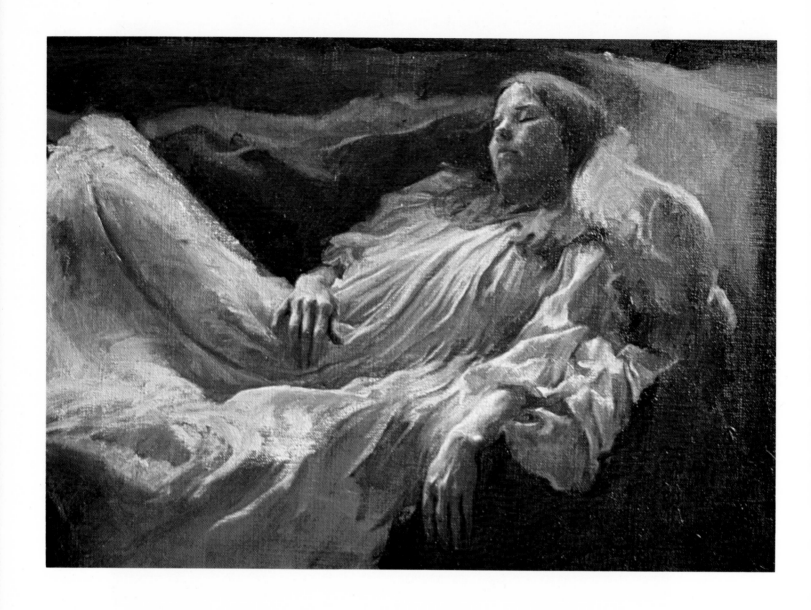

Step 5 (detail). Note the difference between the left arm, where Pfahl has worked extensively, and the leg, which is comparably unworked. Working in sections is the only practical way of depicting the motion of cloth upon the body. See also how much warmer the dress material is in the worked area due to the addition of color. Until now, it has been largely the actual tone of the canvas.

Step 5 (detail). Pfahl has done considerable work here, yet the painting remains fairly soft, with a simple progression of values. The head seems to fuse with the darks of the neck and the hair, and no sharp dividing edge exists anywhere. By fusing forms, the illusion of reality is served better than by the inclusion of hard, precise edges.

Step 5 (detail). This closeup of the hands shows how much work Pfahl has done on them since Step 2 (page 68). Essentially, they are finished here. The drawing is exquisite and true to life. If a girl has drifted off to sleep while reading the paper, isn't this the way her hand would look? You can now appreciate how important it was to close up the fingers somewhat. Every element—no matter how apparently minute—must be carefully resolved in a painting.

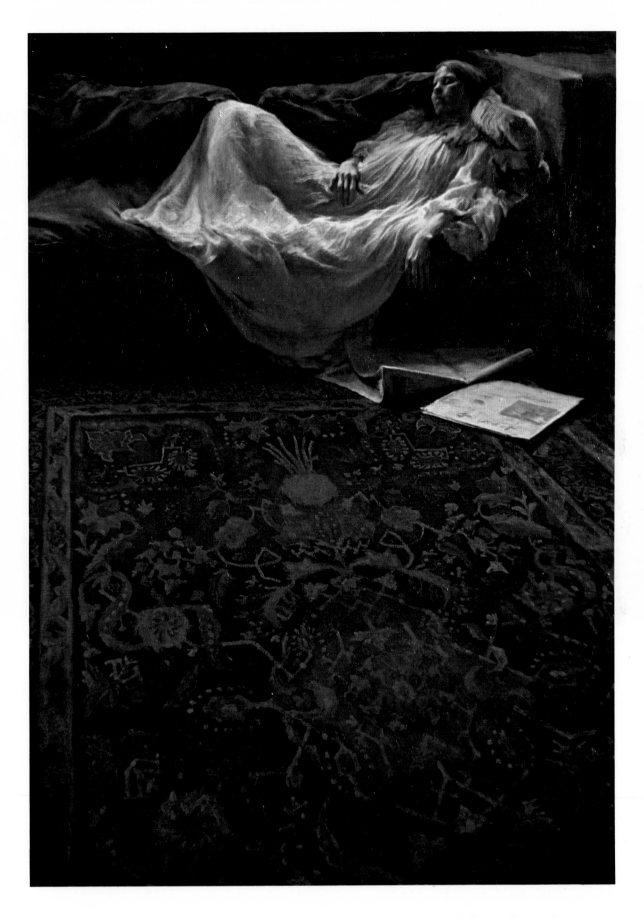

Step 6. Feeling that the tone of the painting is becoming too cool, Pfahl glazes down some areas with ivory black and Maroger medium, and adds warmer accents to the dress to compensate for the additional cools of the blue carpet and the oyster-colored couch. Tones are added to the newspaper to simulate the illusion of print and photographic images. Pfahl now focuses his attention on the lower part of the body and begins to finish up the material of the dress as it forms around the legs and drapes across the front of the sofa.

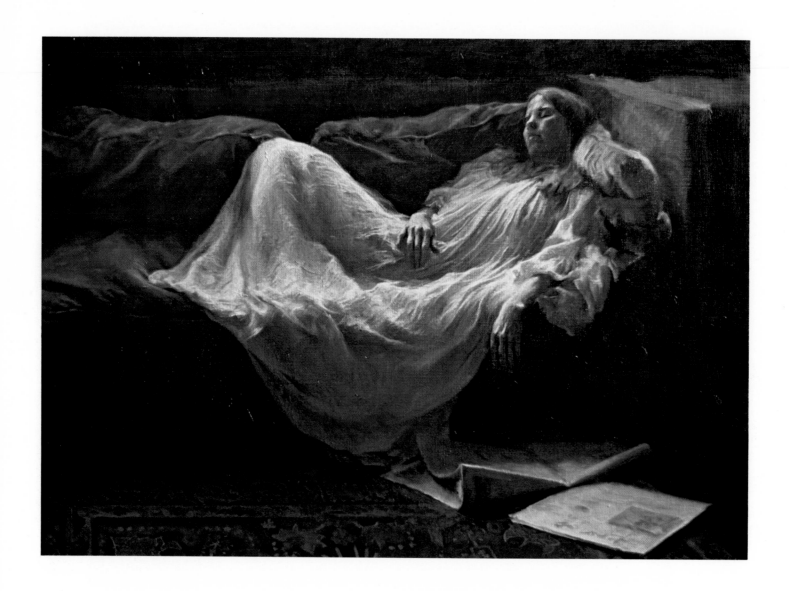

Step 6 (detail). Here we see that the material in the leg area boasts the same degree of finish as that previously completed over the arms and chest. The dark area that follows the shape of the bottom of the figure against the couch is vital for clarifying the pose. Accents such as this also add depth to a painting. All the smaller folds, pleats, and wrinkles are merely icing on the cake—handsome, but not as important.

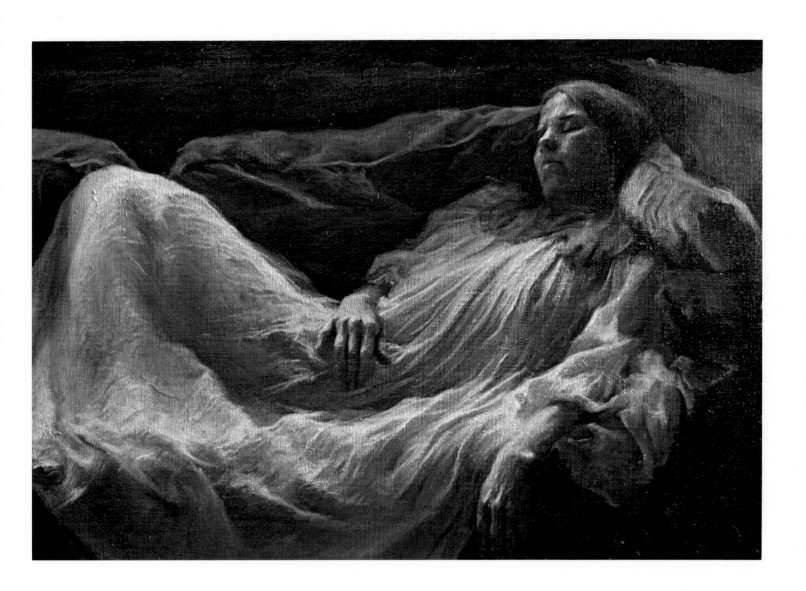

Step 6 (detail). The model's legs are leaning away from the viewer and resting against the cushions of the couch. Pfahl accentuates this effect by showing the valley of cloth formed between the knees and the front of the couch. We get the feeling that the girl's feet are close to us, almost at the edge of the couch. This is a natural position for a sleeping body, since all muscles relax in sleep.

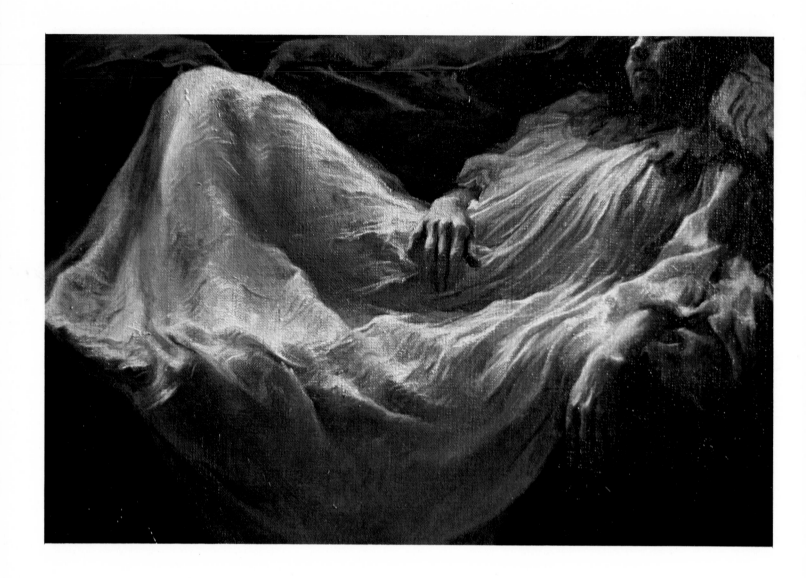

Step 6 (detail). The drape of the cloth over the edge of the couch is an important compositional accent—it helps promote the feeling of a reclining figure. By accentuating this strong vertical downward movement, Pfahl subtly guides your eye in the direction he intends it to follow. Cover the length of cloth which hangs off the edge of the couch and see how this weakens the effect Pfahl is after. The experienced painter employs every useful device in designing the total picture.

Step 7 (detail). Notice that the section of finished carpet in this closeup is no more precisely executed than the previously shown areas. This only goes to prove that it is not the degree of finish, but the total effect that convinces the eye that more detail exists than is actually there. This is a principle you might want to apply to your own work.

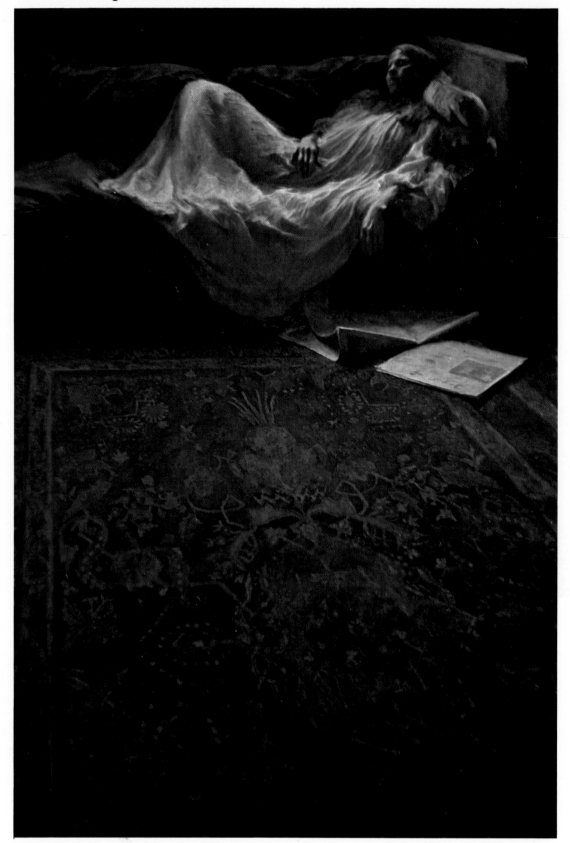

SUNDAY TIMES. Oil on toned canvas, 24″ x 36″ (61 x 91.5 cm), collection of the artist.

Step 7. This step involves only glazing. Pfahl returns to the area of the carpet closest to the couch and grays it even further by glazing the area in question with an opaque white tone. This misty glaze softens and plays down all the colors and values. He then strengthens the value contrasts and brightens the colors in the closest area of the carpet to further promote the illusion of the receding carpet. Small, but vital, refinements such as this give a painting its power, impact, and veracity.

Despondent (study). Pencil on paper, 11'' x 14'' (28 x 35.5cm), collection of the artist. This is a very rough sketch designed to show Pfahl where the darks of the figure occur. For a major painting of this size, this may constitute one of a dozen of such preliminary steps. Other preparatory studies may include line drawings, tonal drawings, and color impact studies in oil or pastel. Pfahl never proceeds to the actual painting without some preliminary work. He prefers to solve his problems before rather than during the actual painting process.

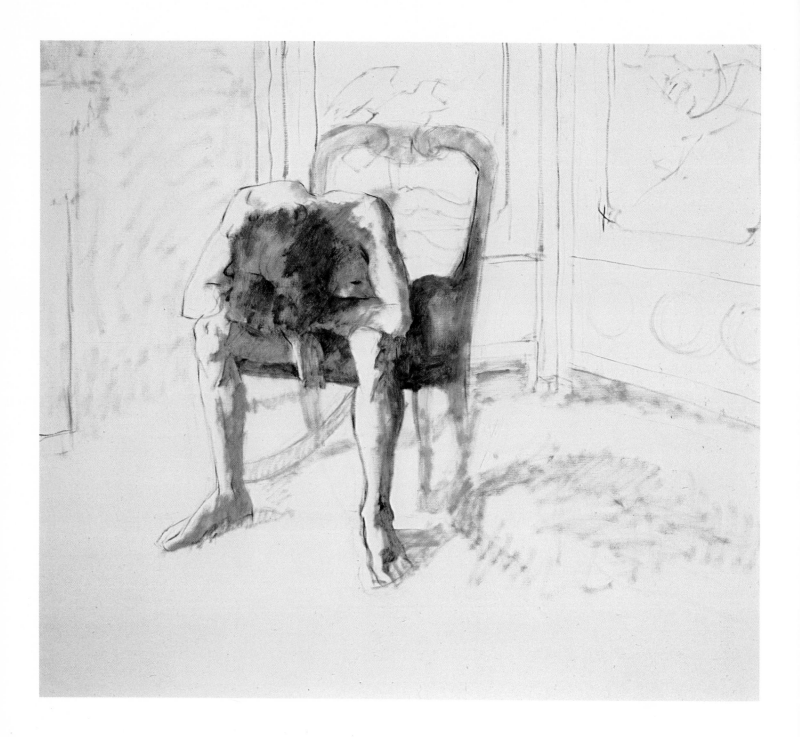

Step 1. Pfahl selected this pose after viewing the figure from several angles. Even though he was fairly sure of the pose, he still moved around to see from which angle it would appear to best advantage. Working on untoned canvas, Pfahl first sketches the pose quickly in charcoal. He then wipes away most of it. Switching to burnt sienna and ultramarine blue in oils, he blocks in the basic darks of the figure and chair.

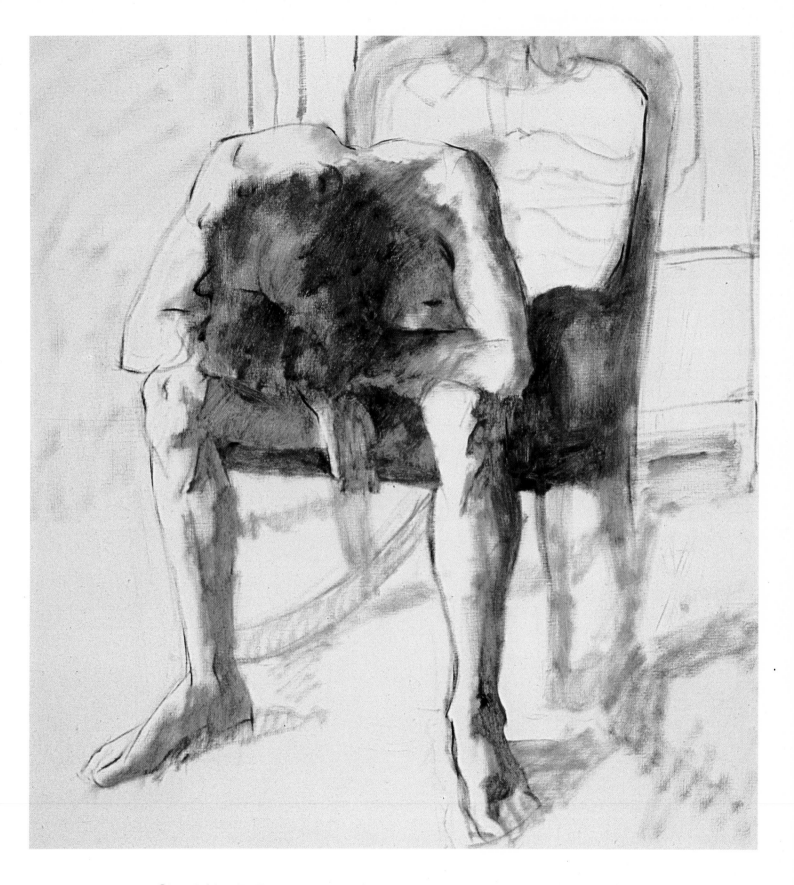

Step 1 (detail). This blocking-in process is accomplished rather quickly. However, the drawing and proportions are quite accurate, since there is little change in proportion or contour between this and the final version of the painting. Obviously, Pfahl's eye is keen and developed and his draftsmanship, mature. An interesting touch is the fact that the model is sitting on a rocker, a type of chair that, at first glance, hardly seems to inspire this kind of pose. But when you look more closely, you can see that the pattern of his head and arms repeats the design of the chair back, and the position of his legs also repeats the line of the chair legs. So the pose is effective as design.

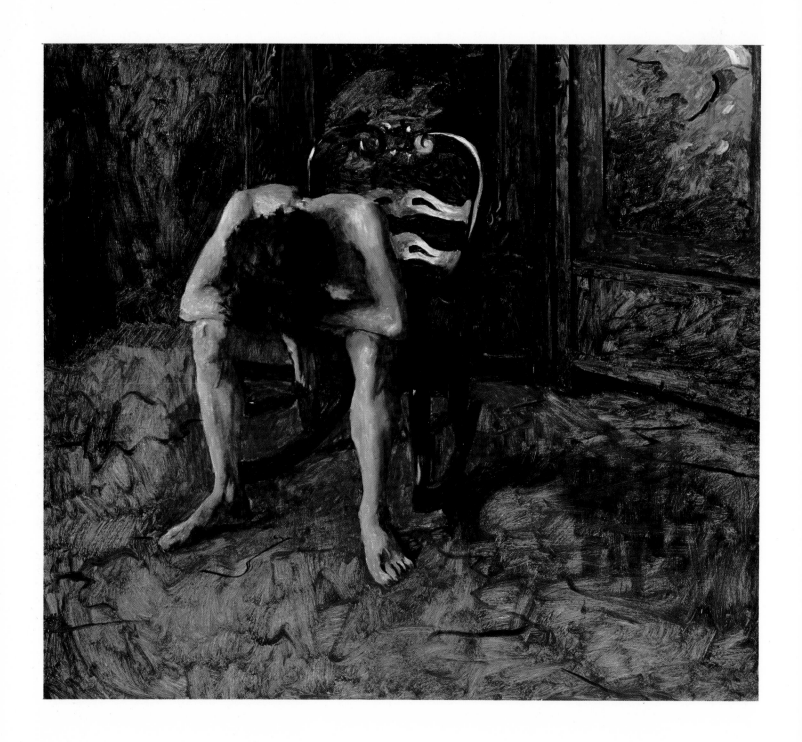

Step 2. In this stage, Pfahl loosely and quickly paints in darkest darks in the hair and the chair. He then uses the side of his brush to work into the shadows in the figure. He uses lots of Maroger medium at this time to render the paint liquid, and moves his brush with all possible speed. This provides him a surface that will be sympathetic to subsequent paint layers. He then goes into the background, trying to approximate the tones of the screen. Now, he moves into the foreground to lay in some tones in the floor. His final move is to lay in a number of broad, light areas on the chair and figure.

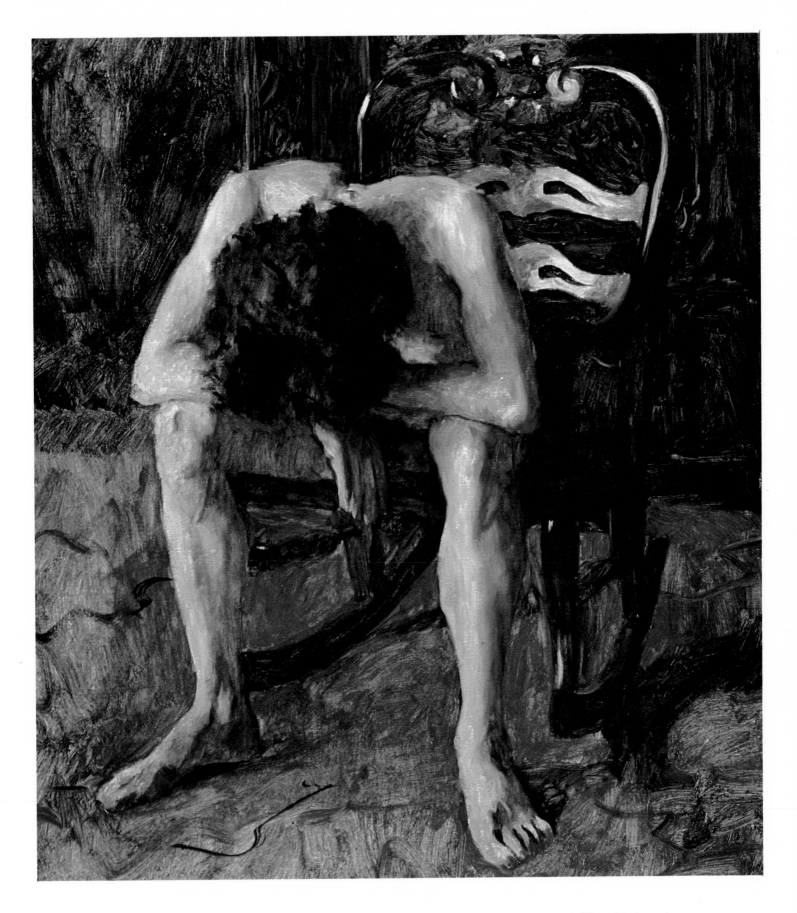

Step 2 (detail). By this stage, the entire canvas has been covered. The skintone is essentially a cool olive yellow with small touches of warmer accents in the hand, toes, and left knee. The lights in the chair are a uniform coolish gray-blue, which is the way a polished brown surface such as wood catches the light. The flesh will be warmed up in subsequent stages.

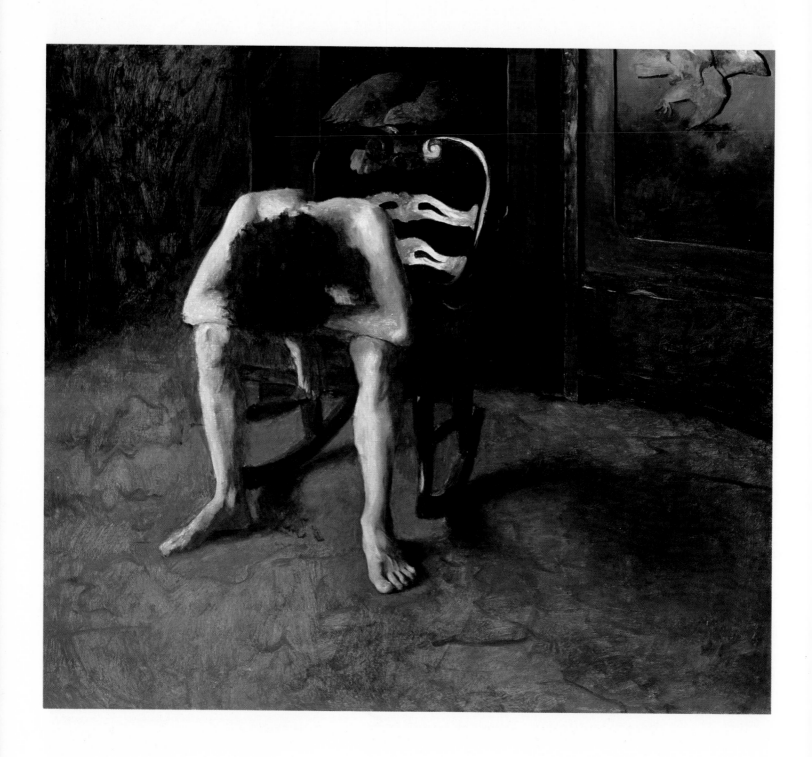

Step 3. Now Pfahl adds strength and depth to the tones he has put down on the screen in the previous stage. He then proceeds to paint the screen in flat values, trying to set the value of the red, of the purple background, and of the gray border. These would serve as bases for the detail of patterns that would go over them. He tries to portray the effect of light hitting the screen in the upper left-hand corner.

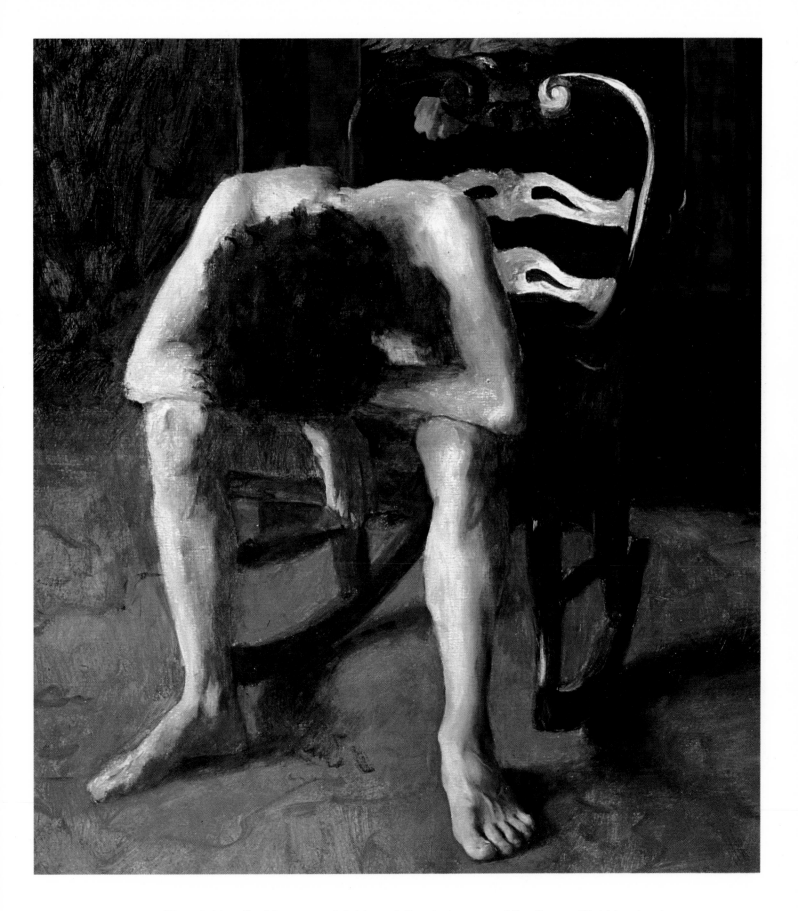

Step 3 (detail). After reestablishing all the dark areas of the figure, Pfahl begins to paint the left foot in its proper color and value. He first fills in the area of floor on which this foot rests to gain an accurate relationship of values. Then he paints the foot carefully, with warm reds on the big toe and on the tips of the other toes. Bluish green accents represent the veins in the foot, which are quite prominent due to the weight of the arm pressing against the knee. Pfahl is under pressure to finish the figure quickly since winter approaches and the studio is becoming too cold for the model to pose comfortably.

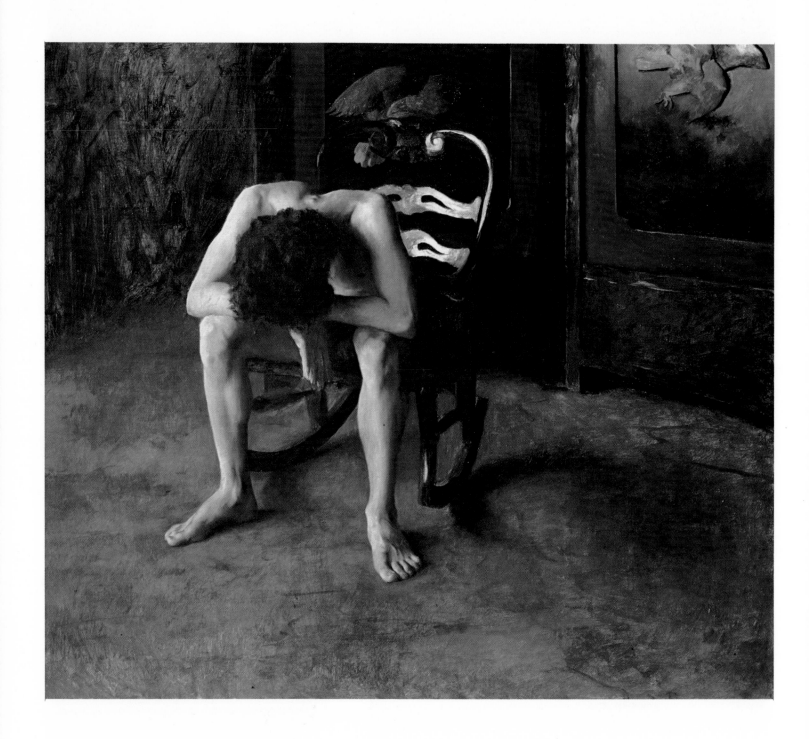

Step 4. The bulk of the figure is now completed. Now he can finish the other elements at leisure since the model is no longer needed. Again, he begins with the foot—the right one this time—and, measuring it against the floor to obtain the proper value, he proceeds to paint this leg as he did the other. Except for the head and the hand, the body is painted in what is still an essentially cool tone.

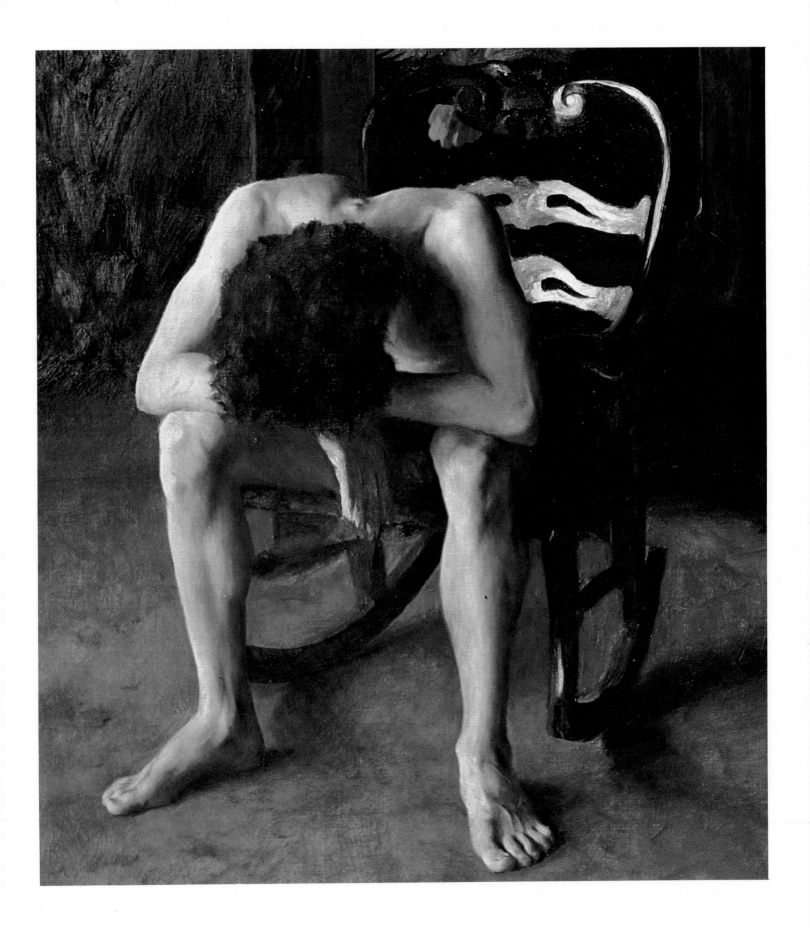

Step 4 (detail). One reason Pfahl is so successful in painting figures is because he has an observant eye. Few artists are so alert to the subtle twists, turns, and actions the body assumes as it settles into various postures. Note, for example, the way the backbone is modeled. The two small bumps denoting the sections of the flexing spine are a touch that lend an immediate sense of recognition. It is the careful addition and selection of this kind of *pertinent* detail that marks good realistic painting.

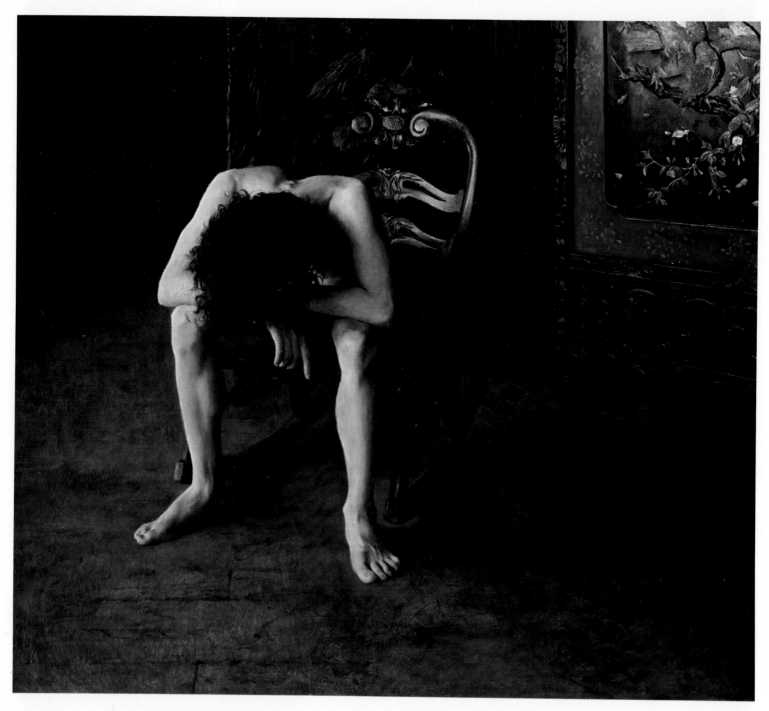

DESPONDENT. Oil on untoned canvas, 44″ x 50″ (112 x 127 cm), collection of the artist.

Step 5. In the final stage of the painting, Pfahl completes the hand and the hair, paying particular attention to those areas where the hair touches the lighter parts of the body. He includes the small light area that falls just above the left forearm. Having previously established all the shapes on the floor, Pfahl now proceeds to finish the floor by glazing the tone down slightly. He then puts in all the detail and patterns of the inlaid screen. After completing the figure, Pfahl spends perhaps three weeks more finishing the other elements in the painting without the model's presence

Step 5 (detail). It is interesting to note how Pfahl warmed the skintones considerably in the final stage of the painting. The colors in the flesh are now richer, brighter, more to the reddish side of the spectrum than before. Note all the carving Pfahl included in the chair. Some painters might have left it out to spare themselves additional work, but Pfahl is apt to paint exactly what is before him once he has determined what he requires of the subject.

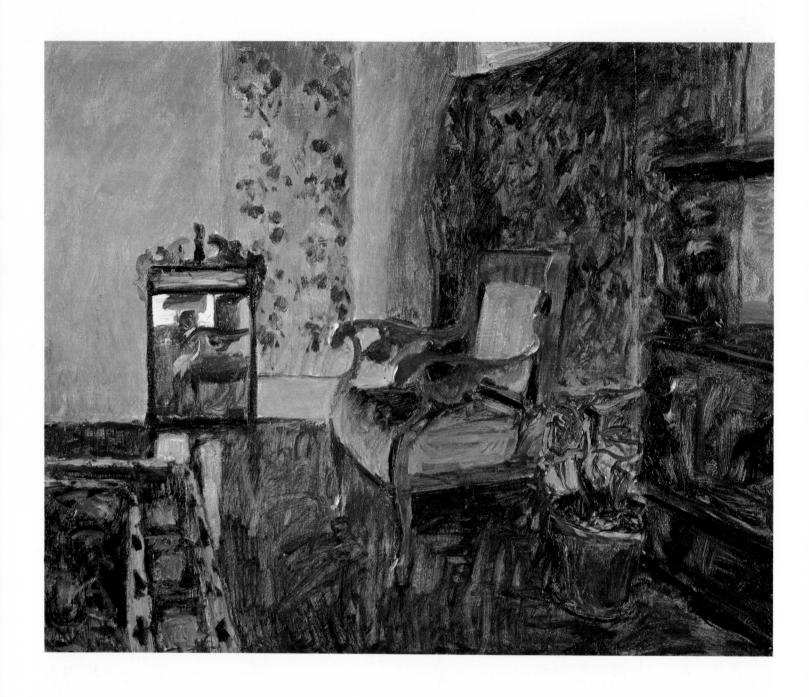

Step 1. On an untoned canvas, Pfahl quickly places the basic components of the entire painting in very rough fashion. In Pfahl's conception, this is basically a portrait of a particular corner of a room. His reason for painting it was to show the various conflicting shapes and patterns in the different elements that are present—the patterns of the leaves, the pattern of the carpet hanging on the wall, the pattern of the piece of silk hanging on the wall, the patterns made inside the mirror, the pattern of the carpet on the floor, and the pattern in the chair.

Step 1 (detail). Working from dark to light, Pfahl first establishes the darks under the chair and those located around the mirror. The idea is to put down the general values first even though he knows that they will not take on the raw canvas and that much additional work will be required to establish their full strength and depth. The work is accomplished quickly, the paint moving easily due to its generous intermixture with the Maroger medium.

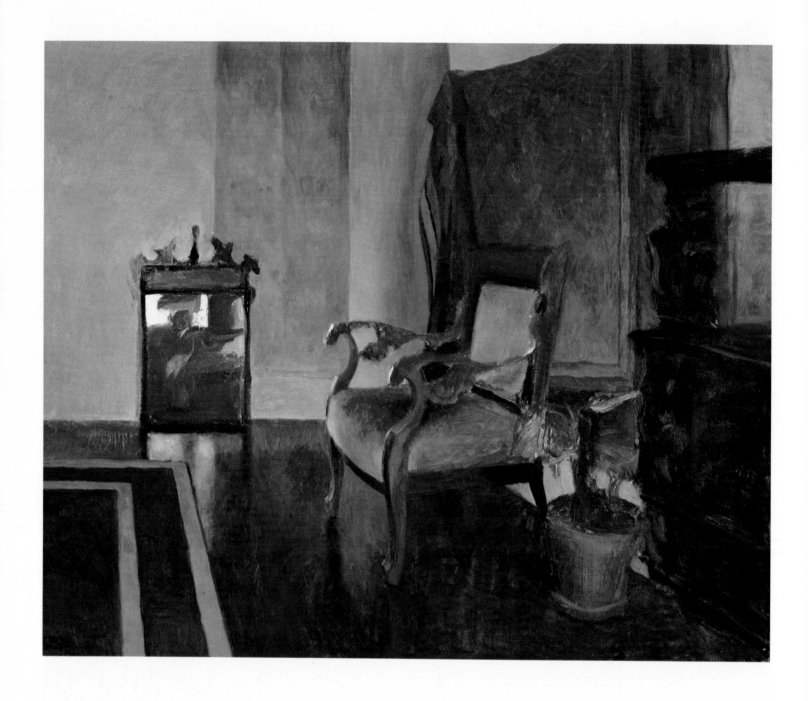

Step 2. Now, Pfahl reestablishes all his darks and middle tones and paints in all the flat areas of the patterned objects. For example, the hanging carpet consists of a yellow ochre background in the center and a blue border and another ochre-toned border. All were indicated as simply as possible, without any thought to the overlying design. The same procedure was followed with the carpet on the floor—getting the blue base and its oyster-colored stripes down on canvas. Attention is paid to folds—the big forms—but, as yet, Pfahl paints these objects as if they had no patterns on them. He is trying to establish their basic shapes and colors as affected by light.

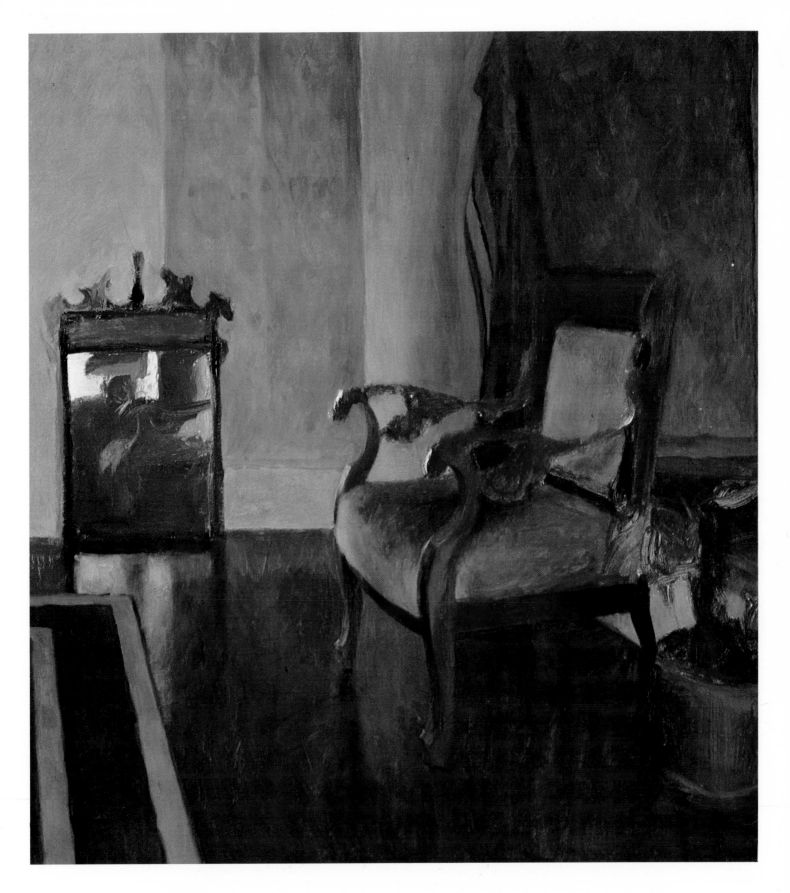

Step 2 (detail). Pfahl is now ready to work out the intricate designs and patterns that first attracted him to paint the picture. Without the preparation that has ensued until now, putting in the overlying detail would be most difficult. But by solving the initial decisions of proper color, tone, placement of shapes, and illumination in the early stages, the artist is not distracted by too many problems in the concluding stages of the picture.

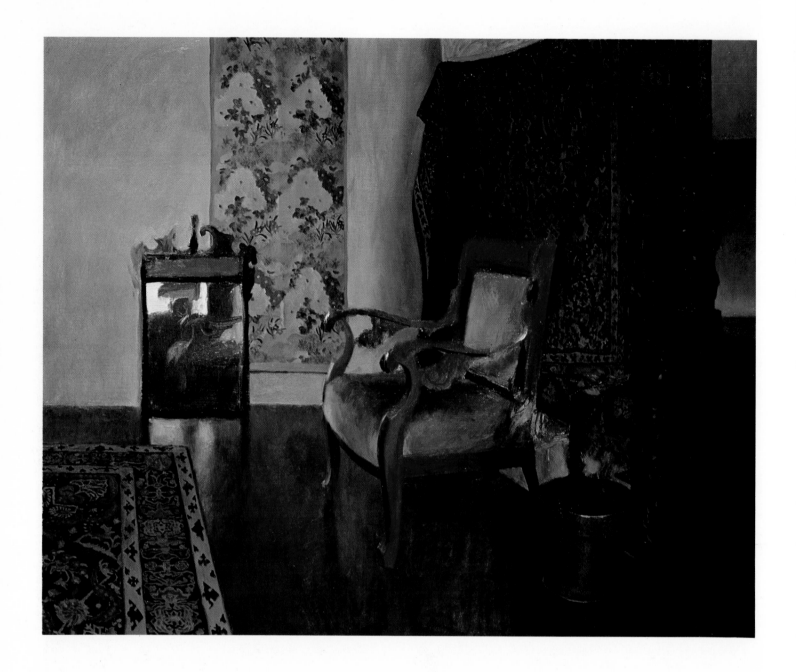

Step 3. Now, Pfahl is able to place all his patterns with accuracy—the hanging carpet, the hanging silk tapestry, the carpet on the floor. These areas are worked out in detail from border to border. Pfahl possesses enormous patience and diligence in tackling such an intricate task. It is only by setting such complex problems that he feels his skills and his ingenuity challenged. By refusing to take the easy way out and by selecting such difficult subjects, he forces his eye and his hand toward an ever-evolving artistic maturity.

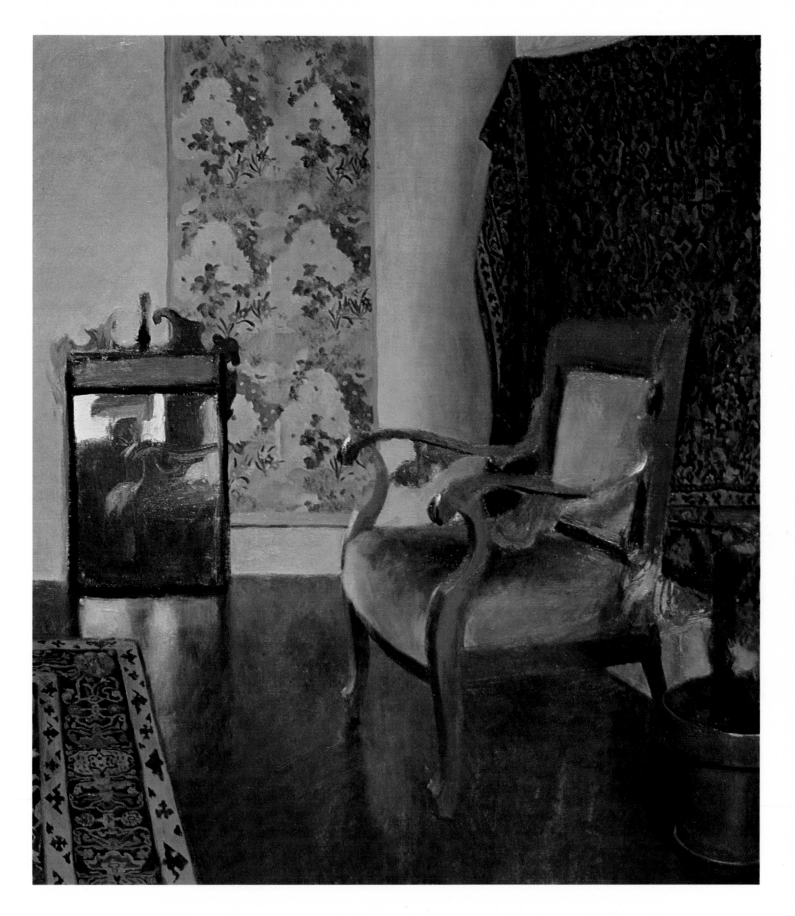

Step 3 (detail). Focusing on the jumble of colors and shapes within the carpet on the wall, you might wonder how Pfahl creates order out of all this seeming confusion. He does so by patiently and carefully painting one area at a time. He selects an imaginary square and concentrates upon that area only, until it is finished, before moving on to the next. Compare this method with that of painters working in looser fashion who work on the entire canvas simultaneously—it is largely a matter of temperament. Pfahl is a very disciplined young man.

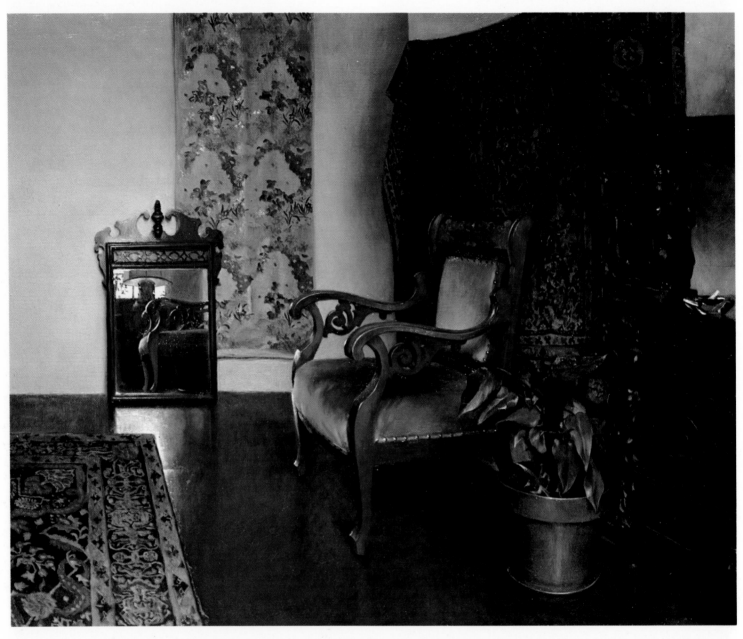

INTERIOR. Oil on untoned canvas, 25″ x 30″ (63.5 x 76 cm), private collection.

Step 4. In the final stage, Pfahl paints all the objects in the picture—the chair, the mirror, the leaves, and the carved dresser. Pfahl also glazes the entire right wall, the shadow under the chair, and the floor to bring down their values. The lights are carefully added, the highest being that just under the mirror on the floor, and the lights in the mirror showing the reflection of the window. The addition of interesting minor details, such as the cigarette butt in the ashtray on the dresser, are characteristic of a Pfahl painting. The viewer delights in such a piquant touch, which he may notice only after having looked at the painting for a long while.

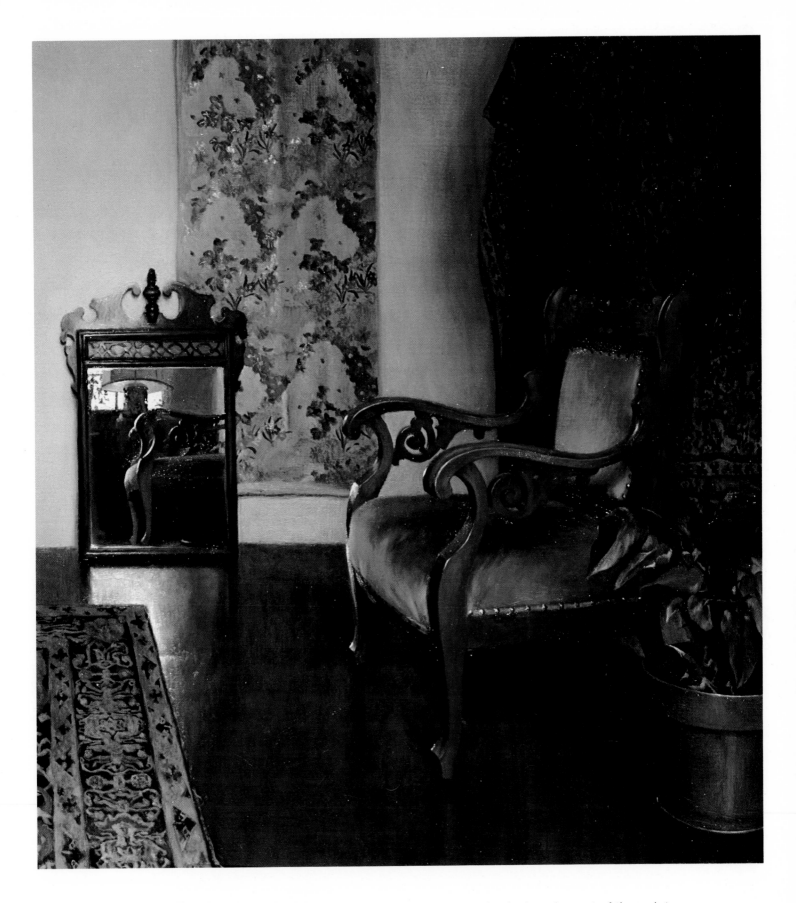

Step 4 (detail). The reflection in the mirror is a most intriguing element of the painting. It almost constitutes a picture within a picture. Pfahl lavishes careful attention on every section of his painting. He doesn't—as many artists do—play up a main area, leaving the rest a vague, indeterminate mass. An essential ingredient in this painting is the cool daylight that settles on each object separately, revealing the many different textures in the scene: the rich, patterned pile of the oriental rug, the velvety chair, the embroidered tapestry, the hard surface of the mahogany, and the reflections in the mirror.

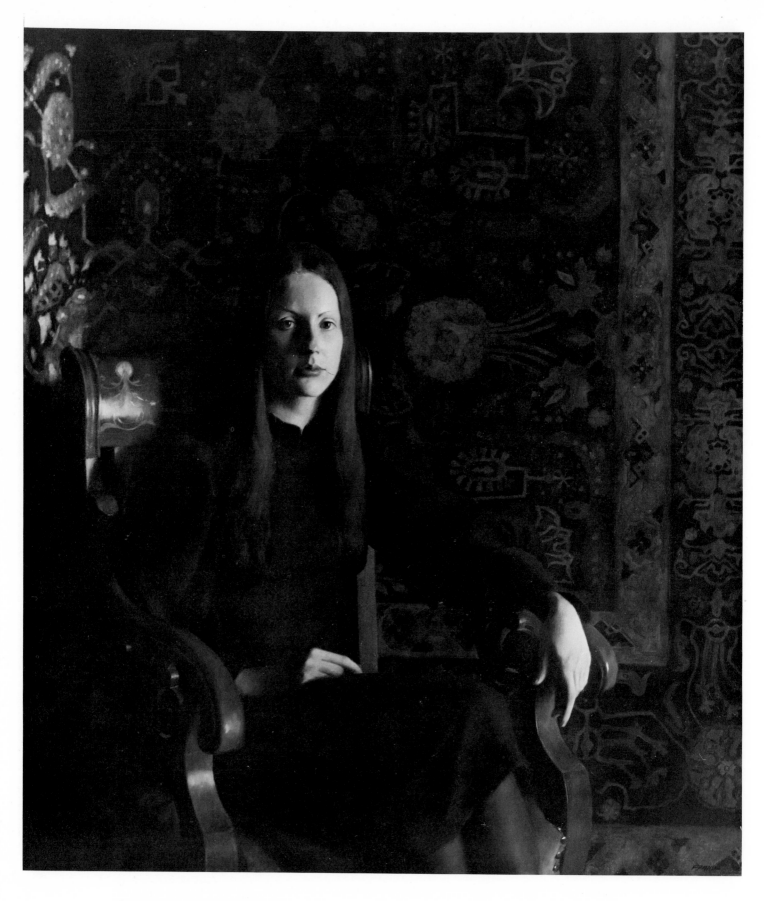

Portrait Against Oriental Rug. Oil on untoned canvas, 40" x 32" (101.5 x 81.5 cm), collection of Mr. Archie Slawsby. This was the first time Pfahl painted an Oriental rug, a motif that is to appear again and again in his work. The challenge here was to paint a figure against such a richly colored background without it dominating the person. Pfahl spent perhaps one week on the figure and four and a half weeks on the carpet, changing the tones, lightening it, experimenting to achieve a good balance of tonal relationships between the rug and the skin tones of the woman. Choosing a redheaded model merely complicated this process even further, but Pfahl never seeks the easy or obvious solution.

One-Man
Show

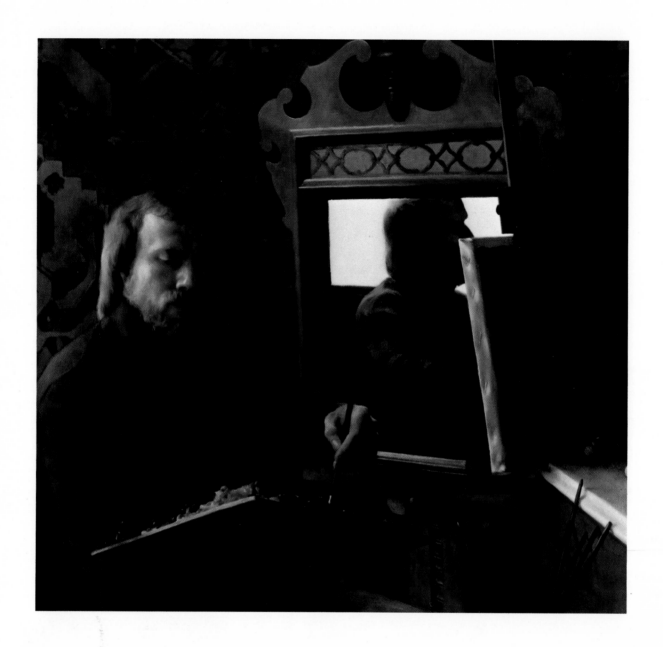

Artist at Work on Self-portrait (above). *Oil on untoned canvas, 30" x 32" (76 x 81cm), collection of Roy E. Abraham. This painting and* Self-portrait in Progress *(on page 139) were both painted at the same time. In such instances, Pfahl sets up two mirrors facing one another so that each time he wants to see his image, he has to look up either to his left or his right. Although he is shown painting with his left hand, Pfahl is, in reality, right-handed. The picture represents a reversed or mirror image of himself. Painting with mirrors is a rather difficult stunt, but it is a marvelous exercise of discipline. Pfahl has to use a hand mirror to catch the expression on his bowed head.*

Black Lace (right). *Oil on untoned canvas, 14" x 12" (35.5 x 30.5 cm), collection Sharon Van Ivan. The focal point of his painting is of bony fingers pressed against a mass of black dress. Pfahl consciously directs our attention to this hand to the exclusion of all the other elements, which drift off into the shadow. Even the head is subordinated to the long, narrow fingers, which are lighter and brighter. There is something old-worldish about this beautifully executed painting. It contains elements of a Degas study in its blend of simplicity and radical composition.*

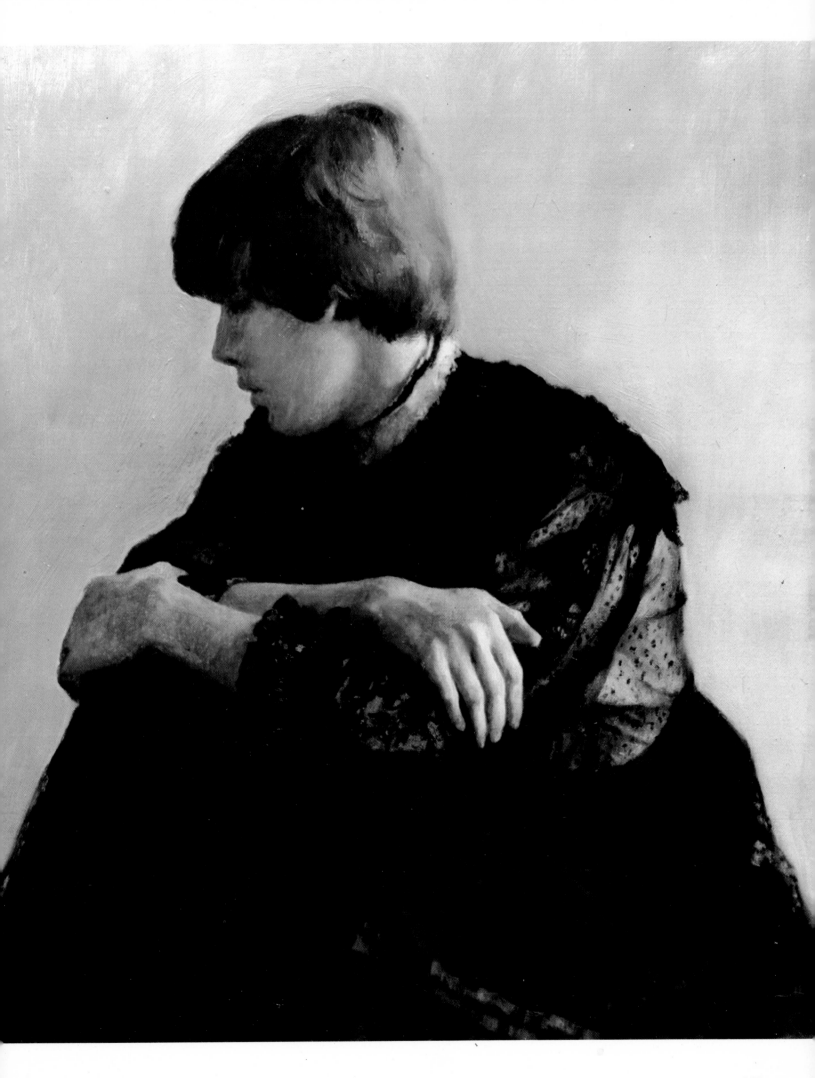

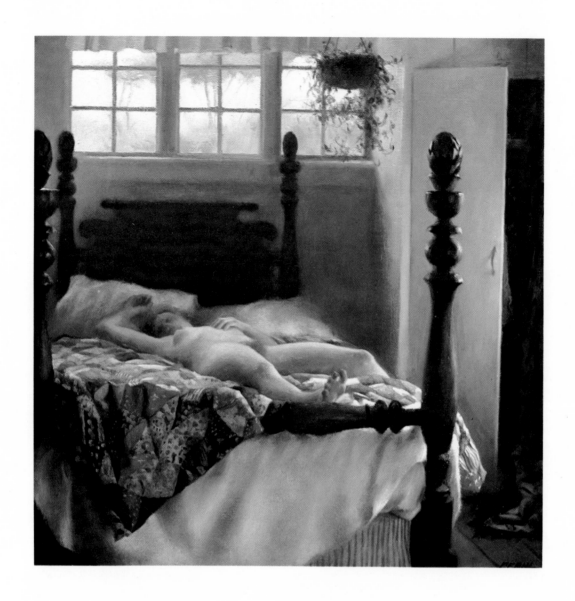

Nude on Quilt (above). Oil on untoned canvas, 16'' x 16'' (40.5 x 40.5cm), collection of the Salmagundi Club. Pfahl chose this concept to show the colorful character of the quilt against the grayish, subdued qualities in the rest of the painting. The top of the reclining figure is bathed in cool light that contrasts with the warm, bright reds and yellows of the material. Pfahl considers this a painting of a quilt with a figure upon it, rather than a figure painting per se. Had he elected to stress the figure, he would have selected a less vivid and imposing fabric.

Nude on Quilt (detail). Note how softly the head is painted. It is almost lost in a reddish middle tone, while the breasts and abdomen catch the full light of the window. Drawing a figure in such radically foreshortened perspective requires an excellent knowledge of anatomy and superb draftsmanship. Seen through a camera lens, the model's foot would have grown enormous in size. Pfahl never paints figures from photographs. Instead, he relies upon sketches; he might execute up to a dozen for such a complicated pose.

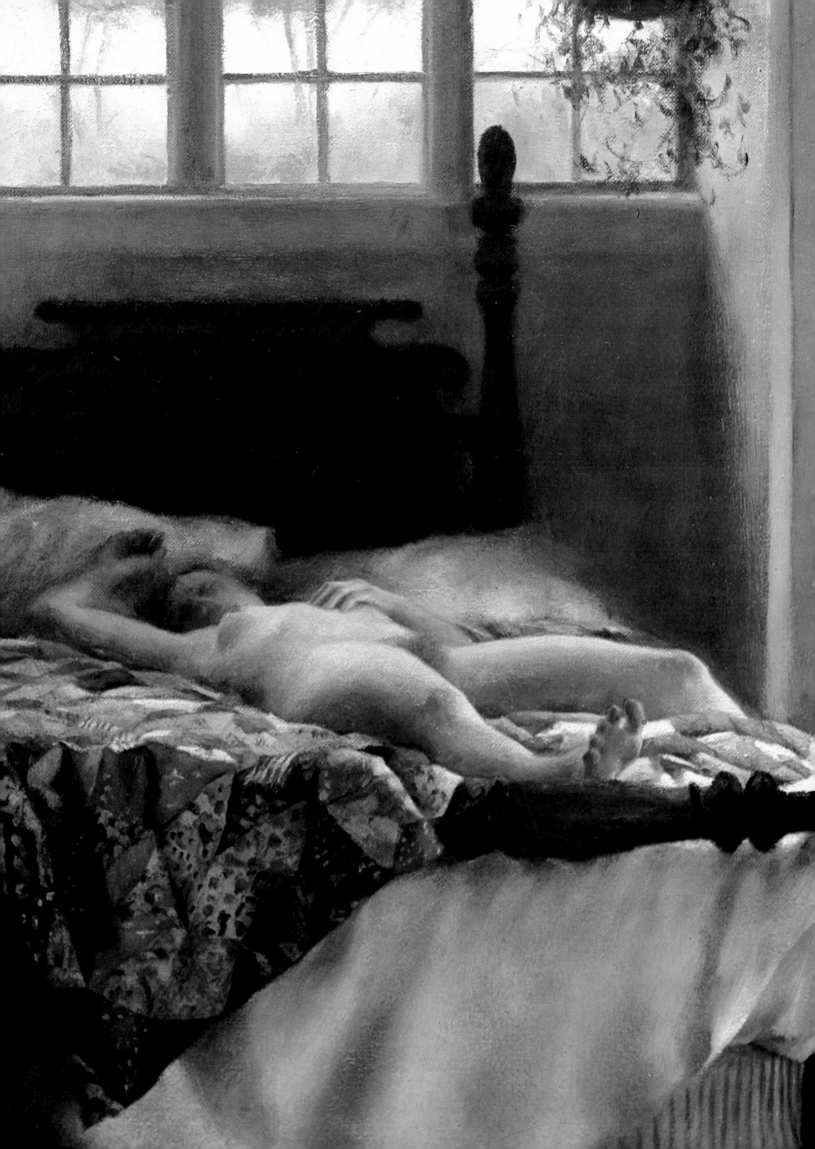

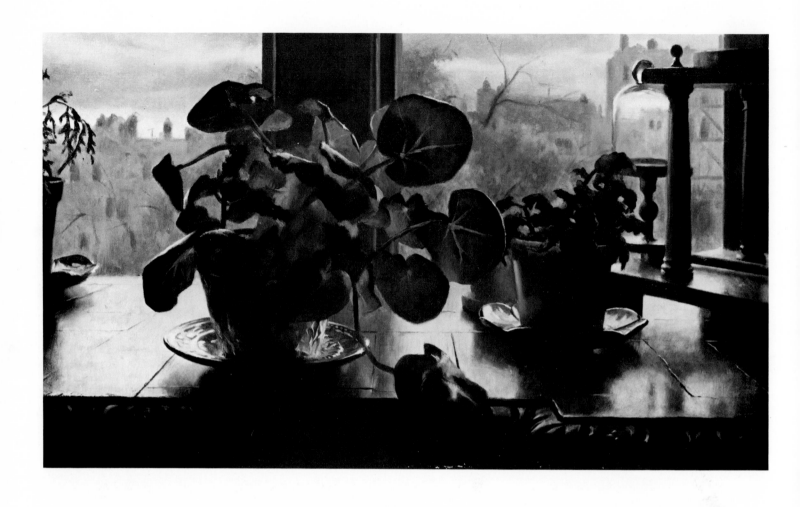

Still Life with Plants (above). Oil on untoned canvas, 16'' x 28'' (40.5 x 71cm), collection of Mr. Carl Lizza. This is a painting essentially in silhouette and back lighting. The design is an intricate interweaving of the lighter shapes of the still life outdoors balanced by darker forms of the indoor still life in front. In this kind of picture, the arrangement and balance of values and forms are the most important factors. Unless the darks and lights are harmoniously positioned, the effectiveness of the entire design will be destroyed.

Early Morning (right). Oil on untoned canvas, 24'' x 16'' (61 x 40.5 cm), collection of Mr. and Mrs. David Winterman. Pfahl often gives the viewer the impression that he, the viewer, is peering into a private room where someone is doing something quite personal. Most paintings of domestic activity suggest that the person or persons so engaged are conscious of this scrutiny, much like actors on a stage. But in Pfahl's pictures, you go away with the impression that the people are so completely absorbed in their activity that they are totally unaware of any intrusion.

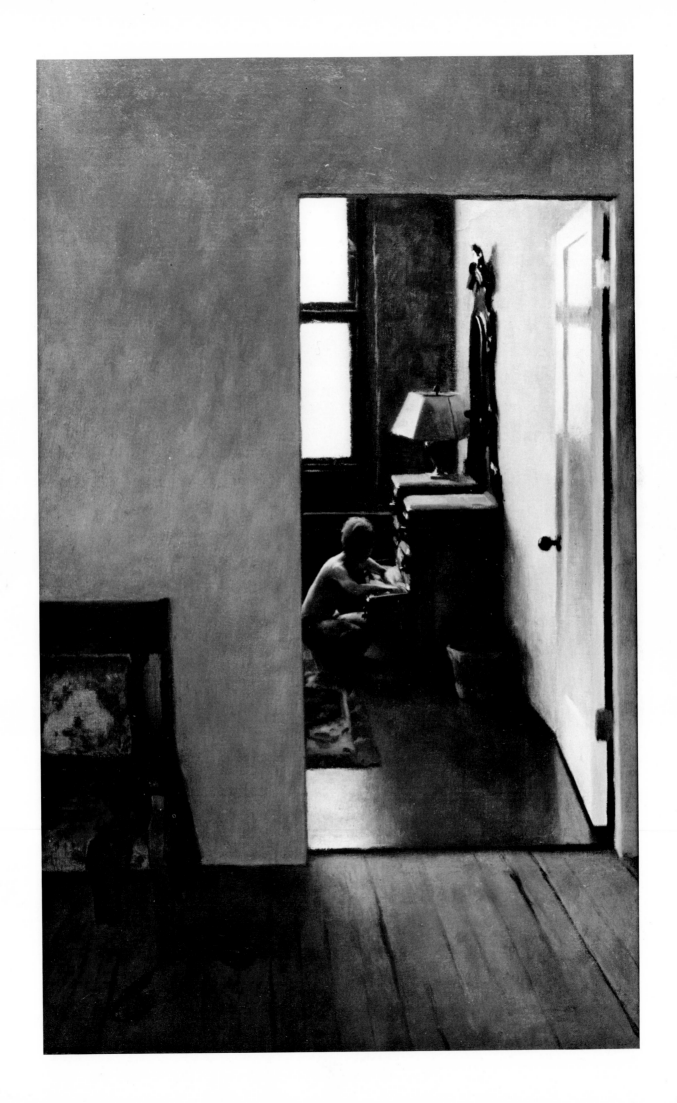

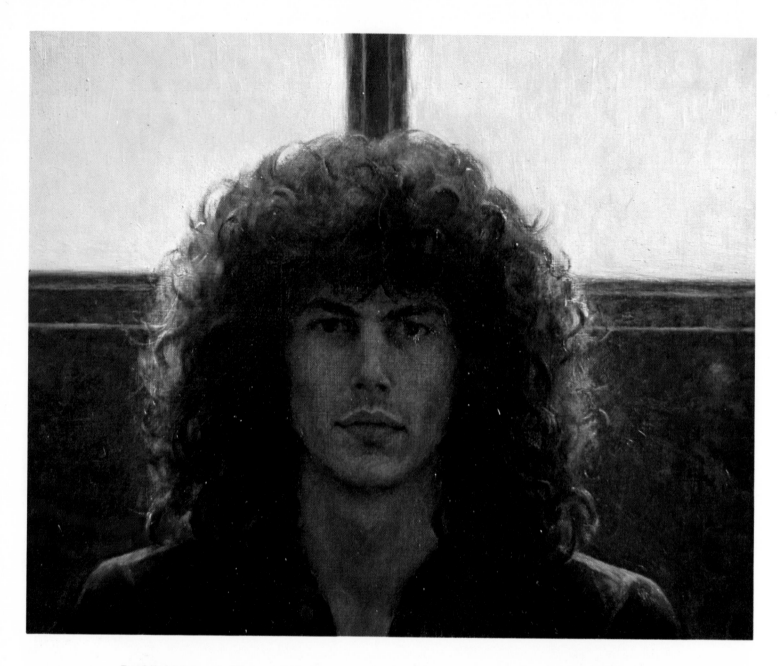

Backlight (above). Oil on untoned board, 18" x 22" (45.5 x 56 cm), collection of the artist. Pfahl sees this painting as symbolic of the crucifixion, with the head placed dead center and the window bars representing the cross. This dramatic effect was most difficult to achieve, since Pfahl had to struggle to maintain the strong light of the window and still preserve a measure of color in the face. Pfahl had to shield his eyes to see the facial tones, which disappeared in the bright glare of the powerful illumination. Achieving a balanced tonal relationship despite this contrast constituted a true tour de force.

Charlotte with Patterns (right). Oil on toned canvas, 60" x 50" (152.4 x 127 cm), collection of the artist. This is Pfahl's most recent painting and took some five weeks to complete. Like so much of his work, it offers dramatic contrasts of mood, color, patterns, and textures. There is an emphasis on the circle motif—the symbol of eternity—which is repeated in the position of her legs, the folds of the dress, the pattern of the tapestry, the buttons on her dress, and even in the shape of her face against the patterned background. Charlotte, Pfahl's wife, sits absorbed in silent meditation, bound within the muffled, shallow space of the tapestries around her. Although physically close enough to touch, her mind is elsewhere. The carefully arranged folds of her dress encircle her, protecting her like some uncrossable, mystical line. The vibrant active patterns in her dress and the tapestry intensify her deep inner peace.

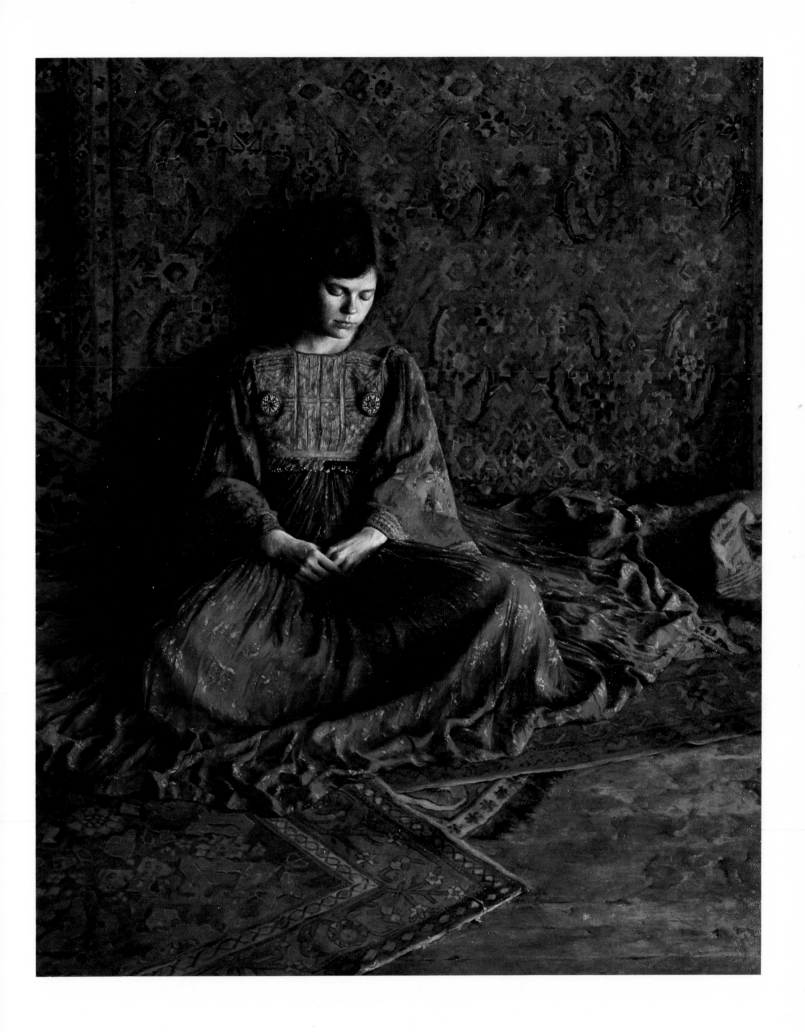

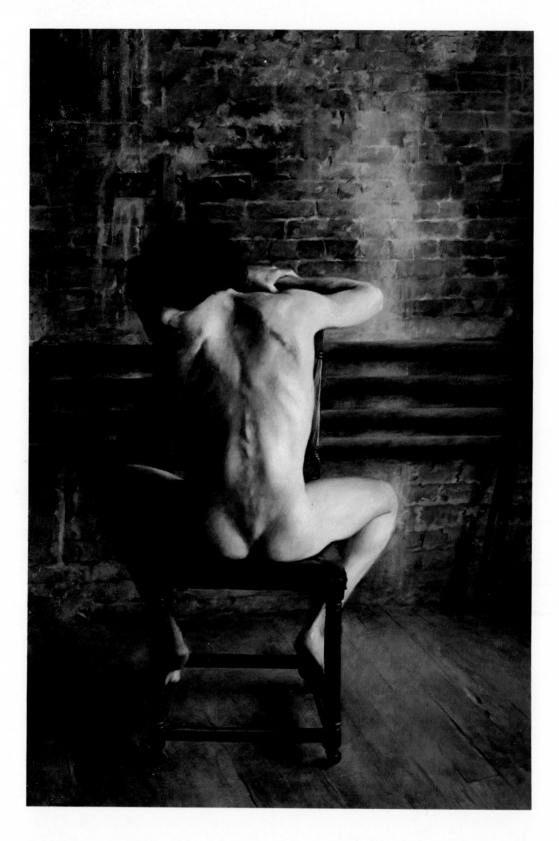

Despair (above). Oil on toned canvas, 60'' x 42'' (152.5 x 107cm), collection of the artist. Here, Pfahl was intrigued by the idea of showing the stark male back against the rough gray of the wall. The model's skin is a particularly pale shade in which greens, purples, and blues predominate. The effect Pfahl was seeking was the harsh reality of the elements as translated into the muted tones of color and strongly affected by the strong horizontals of the pipes on the wall running just behind the model's torso. The boniness of the protruding spine is a subject that appears several times in Pfahl's paintings.

Despair (detail). A raking side light intensifies the deep shadow patterns and emphasizes the texture of the skin drawn taut over the bones. Colors and shapes in the figure and background are carefully integrated: the tones of the wall are repeated in the floor; the railings on the lower wall protrude like ribs; the bricks and chair legs unite in a rhythmical design.

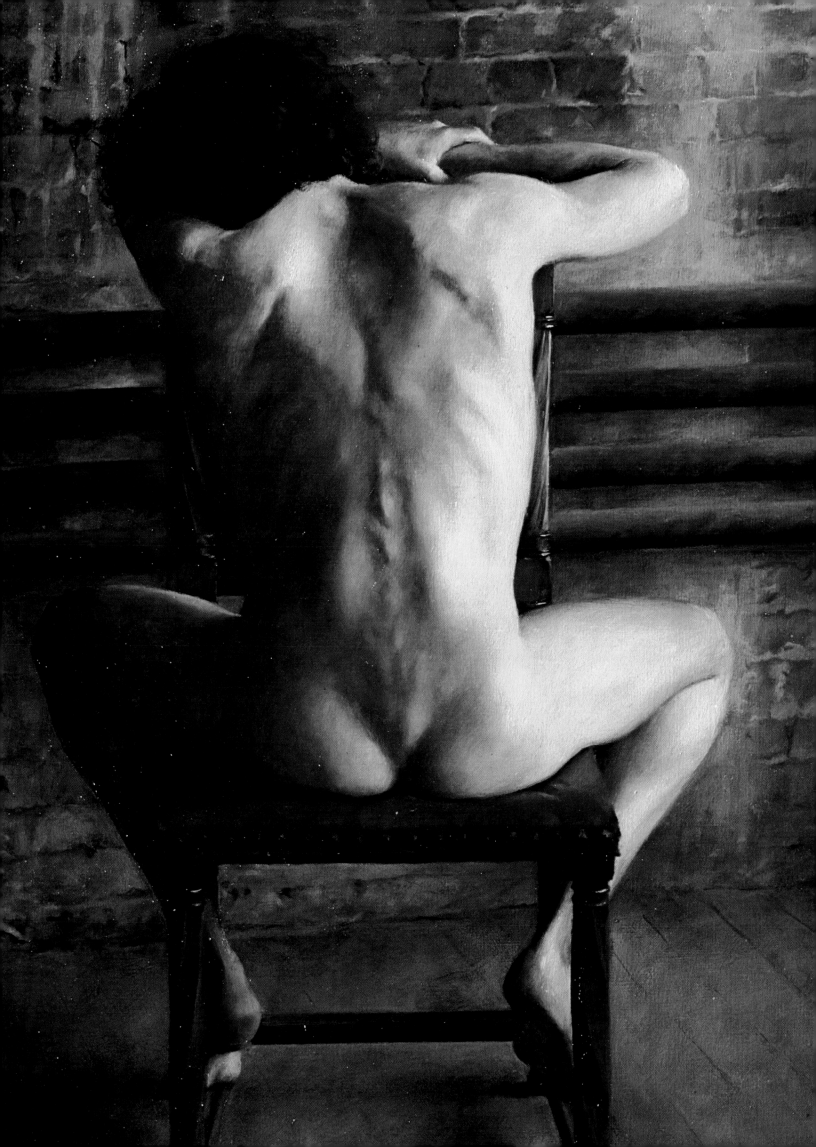

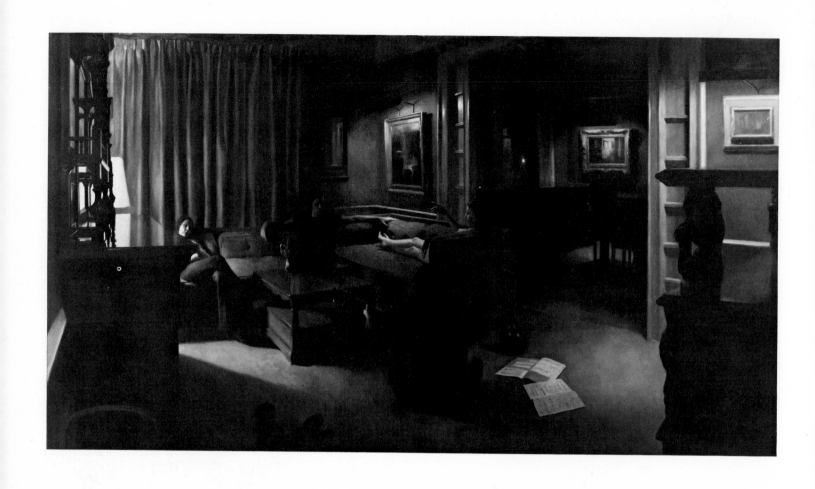

Conversation (above). Oil on toned canvas, 40'' x 72'' (101.5 x 183 cm), collection of the artist. This is one of the largest paintings Pfahl has ever executed. He constantly goes from a very small to a very large canvas, unwilling to lock himself into any particular size canvas or any other such prescribed format. The actual dimensions of the room were exaggerated. One woman posed for both female figures and one man for both males. Oddly enough, Pfahl encountered some objections to the fact that one of the women is seemingly posed nude. However, she was actually dressed in a halter and shorts.

Study in Light (right). Oil on toned canvas, 48'' x 24'' (122 x 61cm), collection of Dr. and Mrs. Skolnick. In this painting, Pfahl attempts a very difficult task—to show the effects of daylight and artificial light in a single situation. Blending two such divergent types of illumination is one of the hardest things a painter can do. The two lights are not naturally sympathetic and they produce a condition that raises havoc with color unless the artist possesses keen powers of observation and the ability to transfer the results of such observation onto canvas.

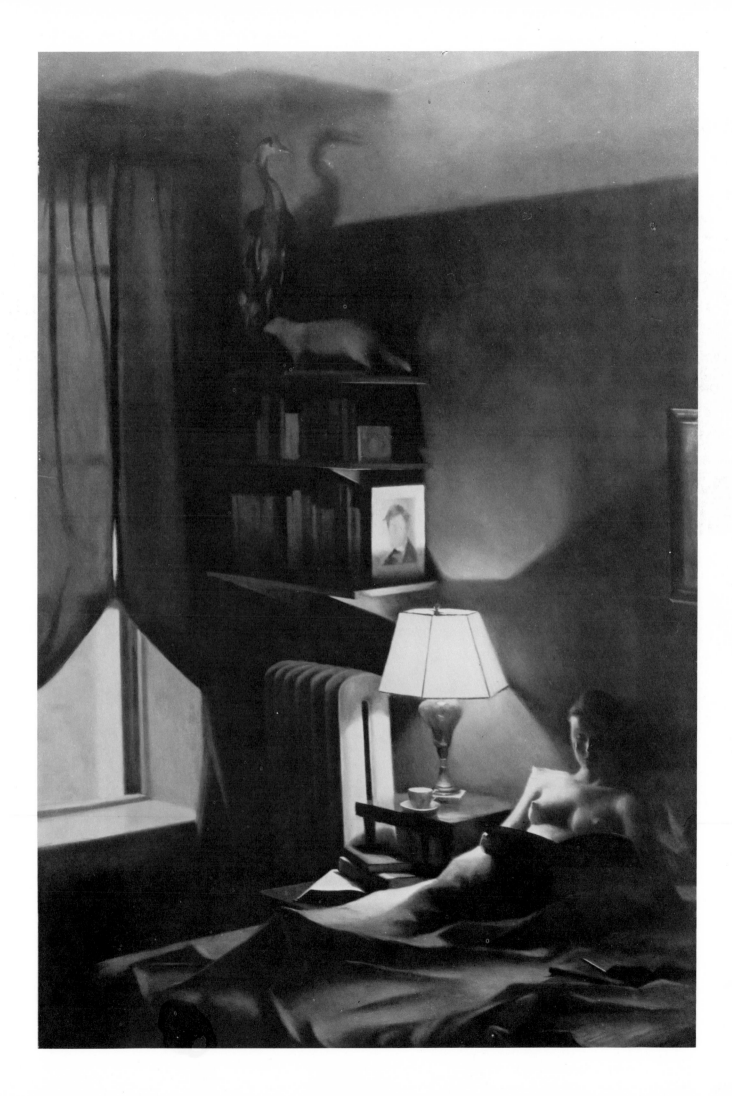

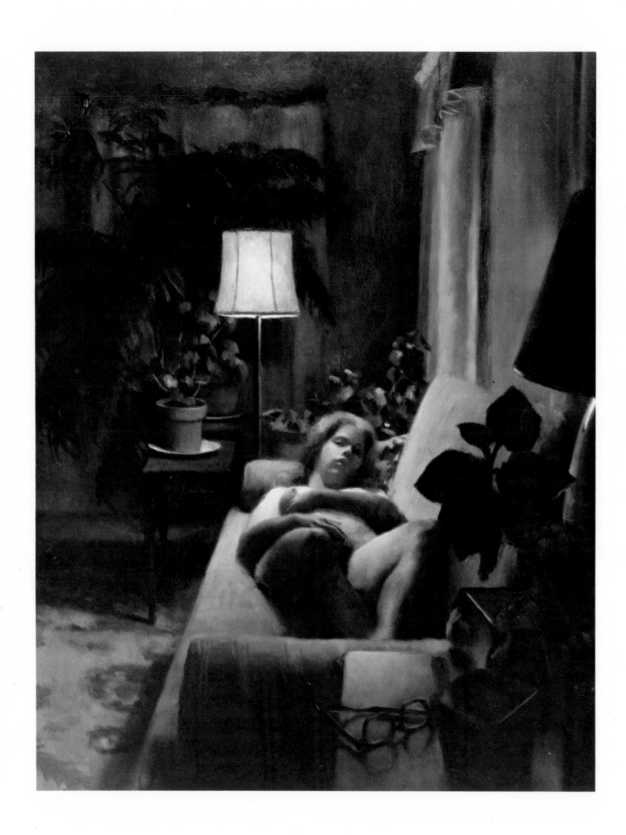

Summer Evening. Oil on untoned canvas, 18'' x 14'' (46 x 35.5cm), collection of Mr. and Mrs. Christopher Burden. When Pfahl paints a picture showing incandescent light, he places his canvas and palette under the same type of illumination that bathes the subject. The lightest value here is on the lightshade, which is normal under such circumstances. The overall color temperature is much warmer than in most daylight situations. Incandescent light, Pfahl finds, tends to rob color of much of its intensity and to lend a yellowish tinge to everything.

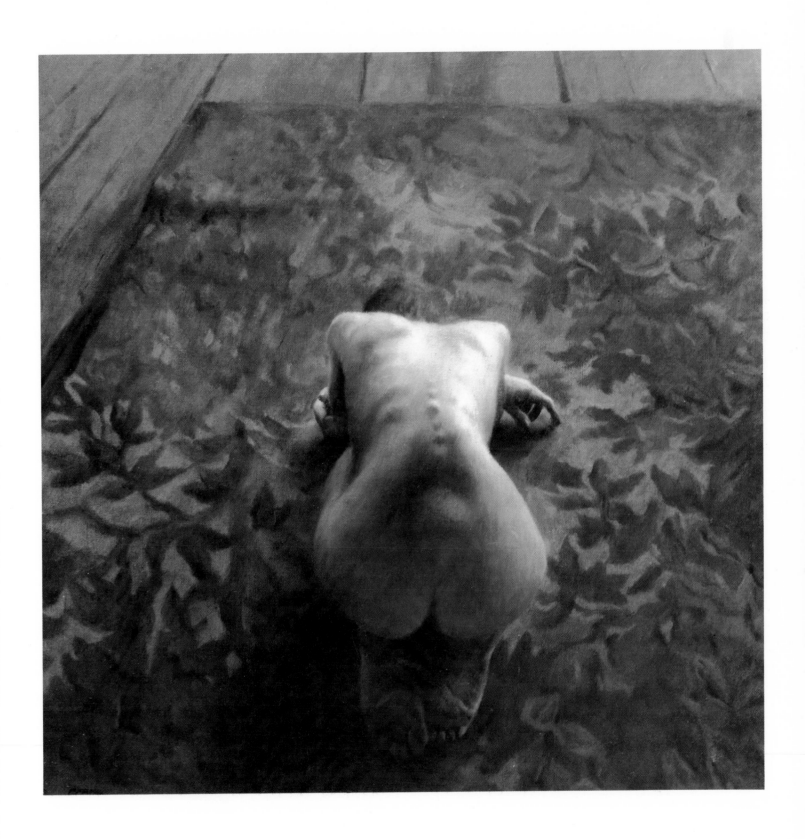

Backbone. Oil on untoned canvas, 30″ x 30″ (76 x 76cm), collection of Dr. and Mrs. R. Welty. Pfahl was fascinated by the way a section of the model's spine protruded when she assumed this rather unusual position, and he proceeded to paint it standing so close to her to be almost above her. It is a most difficult pose to carry off, but it works here because of the subtle transition of the planes in the body as they recede toward the head. Pfahl was working here with a canvas of much rougher tooth than usual. When the painting was finished, he had to cover up all the little bare spots of unpainted surface. He did this by toning the entire picture, except for the light areas, with a grayish glaze.

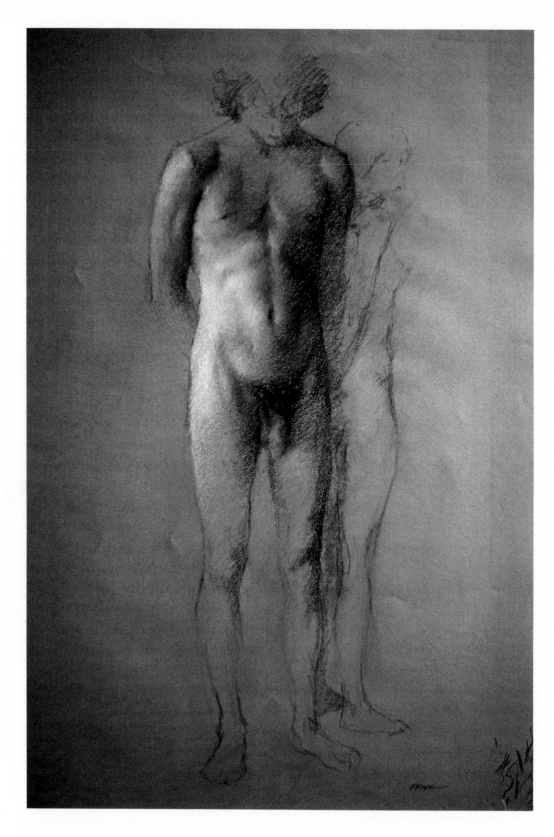

Pastel Study (above). Pastel on paper, 30'' x 20'' (76 x 51cm), collection of Sharon Ames. Pfahl considers his pastel technique one of drawing rather than painting, because he leaves the paper untouched in the background. The result is that the figure seems to be emerging from the atmosphere, represented by the tone of the paper. He builds his tones thinly, never piling the pastel high, but using the tip or the side of a 1'' (2.5cm) piece to crosshatch or juxtapose the strokes. The cools and warms of the flesh are adroitly balanced and the paper itself serves as much of the actual figure.

Pastel Study (detail). This closeup of a pastel study shows Pfahl's familiarity with both male anatomy and with the media. The subtle gradations of tone, particularly in such areas as the lower abdomen, are most pleasing and very characteristic of the human body. Although Pfahl now reserves most of his pastel work for preliminary studies for oil paintings, he expects to execute finished works in pastel in the future.

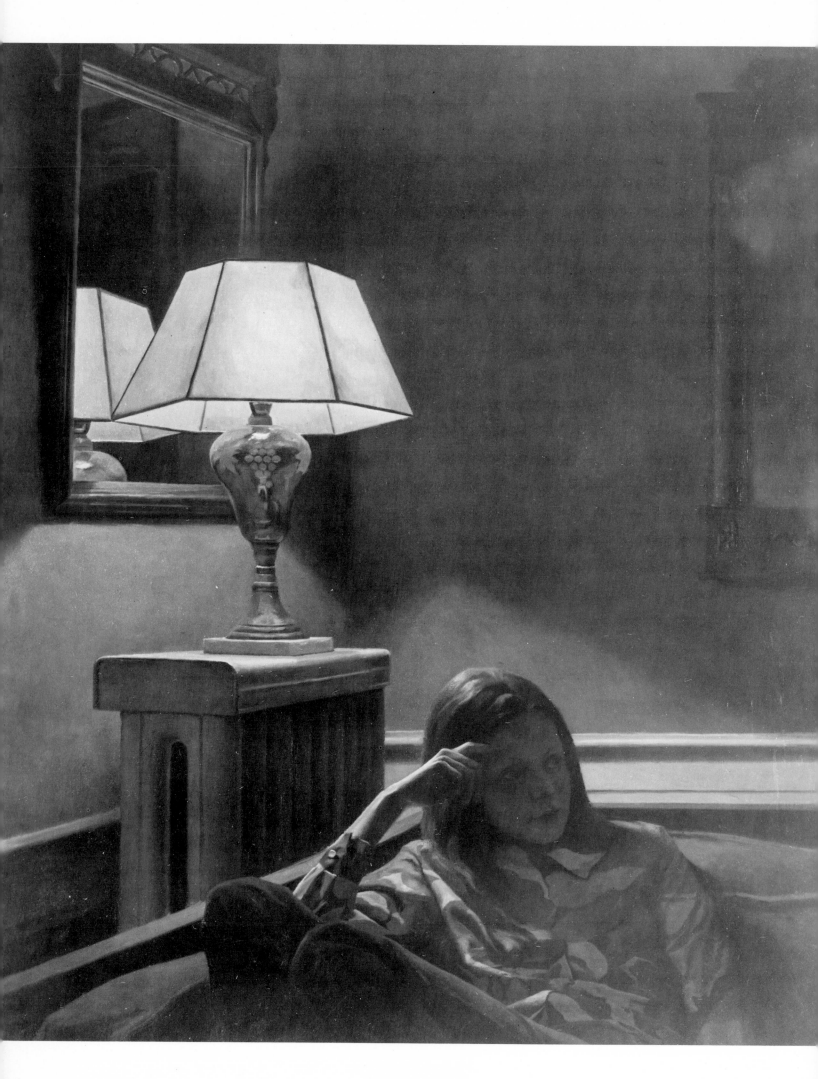

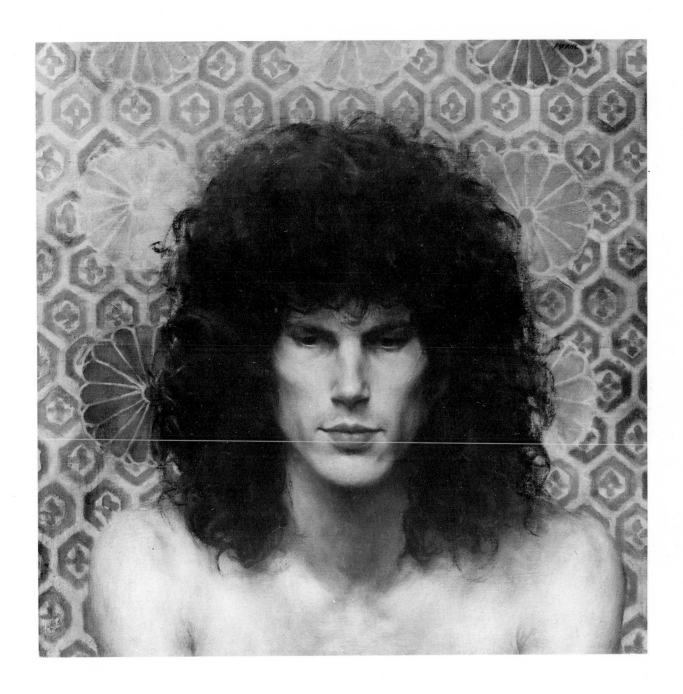

Diego (above). Oil on untoned canvas, 20" x 20" (51 x 51cm), collection of the artist. This is another instance of a head centered on the canvas, the bridge of the model's nose is precisely in the middle. Pfahl does not do anything to beautify his subjects. He paints them in all their introspective intensity, absorbed in their own thoughts and problems and not consciously "posing" for the world. We cannot guess what the moody young man is thinking, but we do know that his emotions are genuine and that he is not attempting to cover up his innermost feelings.

Reflection (left). Oil on untoned canvas. 25" x 30" (63.5 x 76cm), collection of Mr. Archie Slawsby. After this painting was supposedly finished, Pfahl moved the other mirror that now appears on the right edge of the canvas from its former position in the center of that wall. In its original position, it too caught the light of the lamp, creating a second reflection which Pfahl considered superfluous. He wanted that side of the wall to be lost in darkness, so he made the appropriate correction. Although Pfahl plans his paintings carefully, on occasion he may institute changes even when far along in the progression of the painting.

Depressed (study). Pencil on paper, 11″ x 14″ (28 x 35.5cm), collection of the artist. To gain the general effect of this essentially backlit pose, Pfahl needed to see where the darks and lights would fall on the stooping form. Rough as this sketch may appear, it provides the artist with a wealth of information regarding the relationships of the tones. Study the sketch and the painting together and note that, despite the lack of detail here, the essentials are basically the same in both.

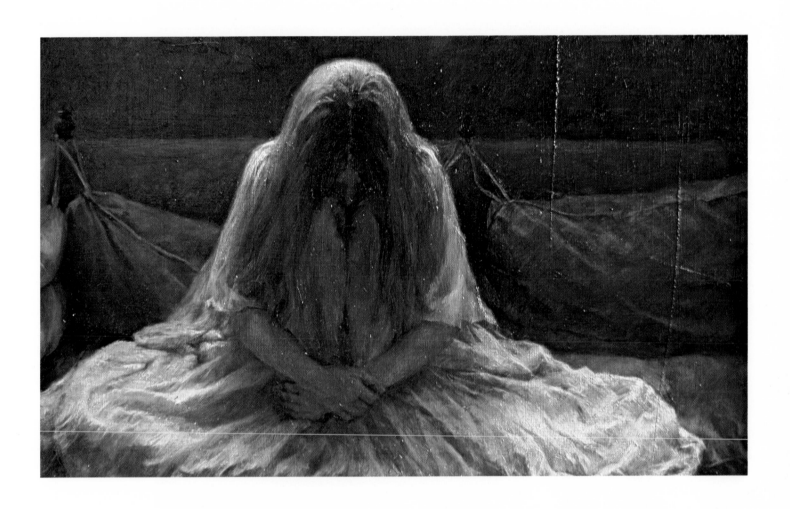

Depressed. Oil on toned board, 12″ x 18″ (30.5 x 46cm), collection of the artist. I consider this one of Pfahl's finest paintings. It captures the mood of depression perfectly without resorting to obvious or gaudy trickery. Technically, it is superb. The folds of the dress are simply but most skillfully articulated. In this painting, which is essentially a combination of gray tones without a truly bright color anywhere, it is the dress that is the focal point. As in this painting, many of Pfahl's figures are shown with faces averted or lost in shadow.

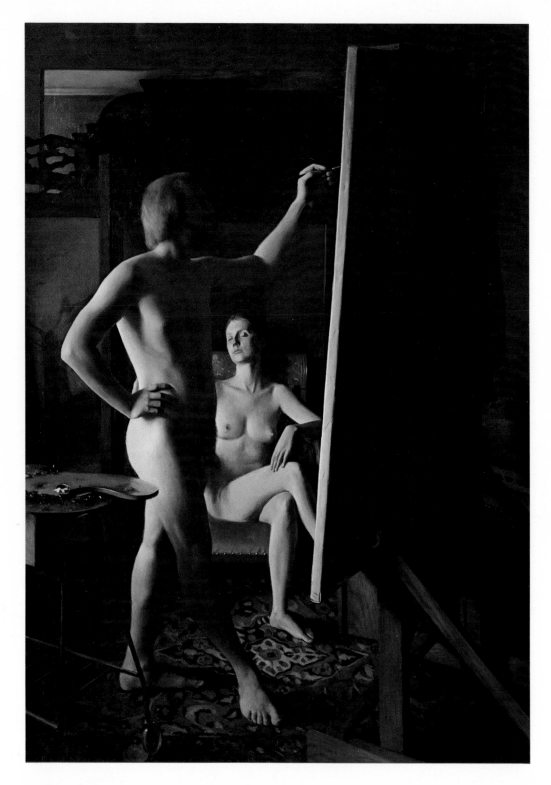

Artist and Model (above). Oil on untoned canvas, 60'' x 42'' (152.5 x 112cm), collection of Mr. Jack Paramore. Although the pose appears somewhat unusual, the fact is that Pfahl does occasionally paint in the nude on hot summer days. This is basically a study in chiaroscuro—strong interplays of lights and darks. Again, due to the mirror image, Pfahl appears to be left-handed. The two figures were painted at times together and at other times separately. The original concept was for Pfahl to paint himself alone, but the model happened to drop into that particular chair and he saw the interesting possibilities of her body posed against the near silhouette of his. The painting was exhibited at the The Three Centuries of the American Nude Exhibition at the New York Cultural Center.

Artist and Model (detail). The stark contrast of value between shadowed silhouette of the male body against the lighter form of the female body provides the powerful impact of this painting. Such chiaroscuro was a feature of many paintings by the masters who were as fascinated as artists continue to be by the effect of strong illumination on form, particularly on the human body. The point of view is also unique; the artist and his model are involved in a subtle interplay of roles, for the artist, too, is the model.

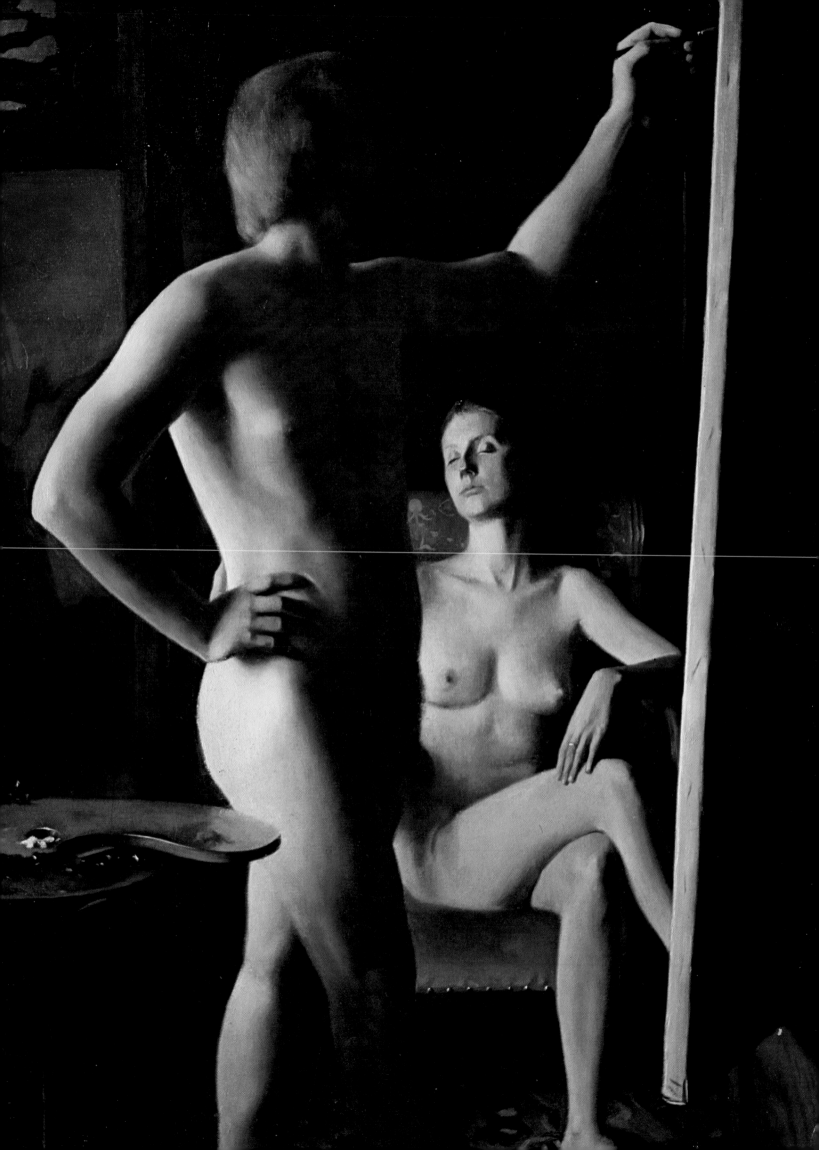

Sea Urchin (above). Oil on board, 8" x 10" (20 x 30.5cm), collection of the artist. This is an example of the type of still-life painting called trompe l'oeil or "fool the eye." The urchin is painted lifesize, with all its fascinating detail. While the pattern in the cloth is kept soft and undefined, the tiny projections in the urchin are delineated sharply and boldly, with great attention paid to particulars. The technique is so lifelike that the quality of its thorny skin is almost felt, as well as seen.

Still Life: Rabbit (right). Oil on toned canvas, 42" x 30" (106.5 x 76cm), collection of the artist. Pfahl considers this painting one of his major efforts. Rembrandt, too, painted a number of pictures showing slaughtered animals hanging on meat hooks. Apparently this subject continues to fascinate artists. The effect here is stark and primitive—the dead beast frozen in death against the gray brick wall that seems stained with its blood.

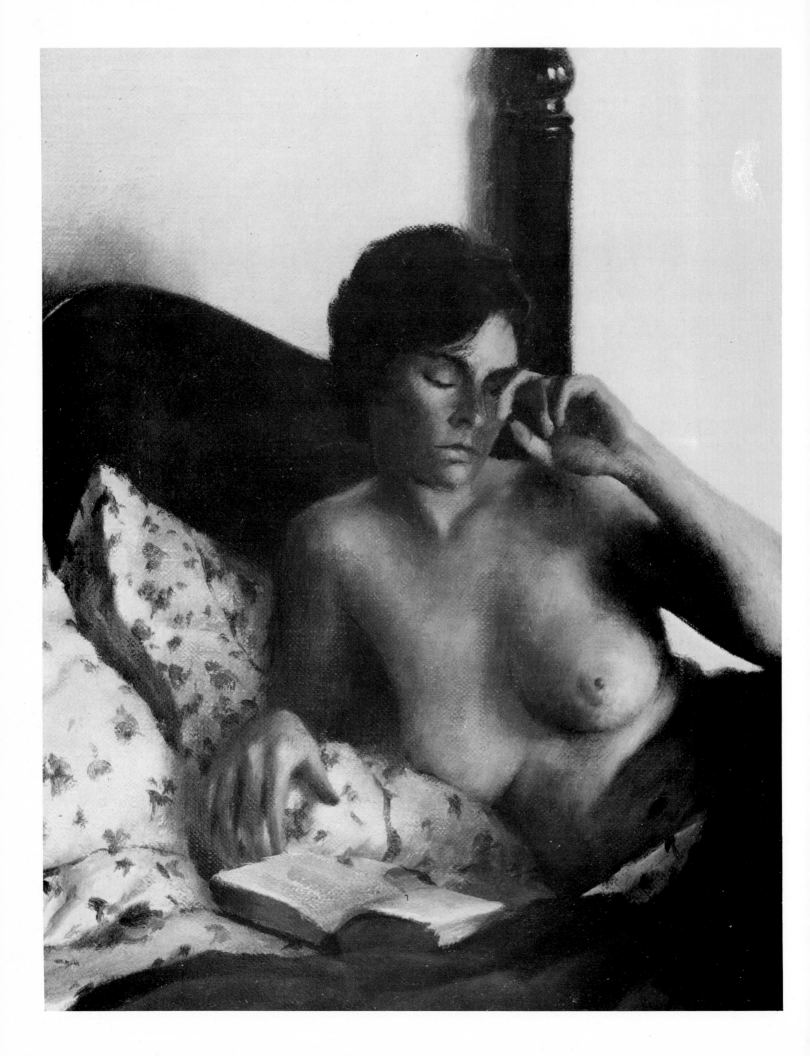

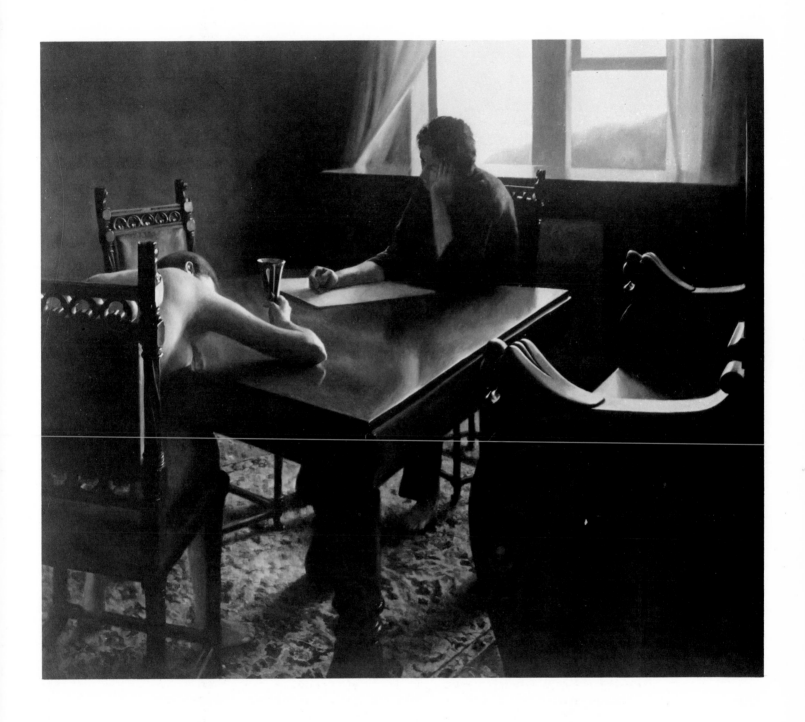

Resting Model (above). Oil on untoned canvas, 25″ x 30″ (63.5 x 76cm), collection of Mr. David Fuchs. Pfahl returns to a recurrent theme—painting the very source of the light itself (the sky or a lamp) rather than merely its appearance on objects struck by this light. Again and again in his work we see the window with bright, dazzling light pouring through to flood the room. Pfahl is obviously fascinated by the quality of light and continues to probe its essence. Another visual effect that intrigues him is that of reflection. In so many of his paintings, the brilliant light causes bright reflections in mirrors and shiny objects such as metal and furniture.

Afternoon Nap (left). Oil on untoned canvas, 10″ x 18″ (25.5 x 45.5cm), collection of Mr. and Mrs. Arthur Bikoff. Here is a small but most interesting study in which the tone of the canvas is seen beneath the thinly laid brushstrokes. Normally, Pfahl's paintings are more thoroughly covered, but this represents the loose, less finished technique that he adopts from time to time. It is unusual to see so much variety of method in an artist who has attained such artistic skill and maturity. Obviously, Pfahl seeks to travel every possible road.

Self-portrait with Monk's Cowl (study, above). Pencil on paper, 8″ x 7″ (20.5 x 18cm), collection of the artist. This is one of the rough preliminary sketches in which Pfahl was trying to work out a pose from his concept. While in some way removed from the final canvas, it does show some insight into the way Pfahl plans his pictures. From this, Pfahl could proceed to the next step, which would be a more careful drawing of the pose itself. It would be interesting to know how many poses Pfahl rejected before selecting this one.

Self-portrait with Monk's Cowl (right). Oil on untoned canvas, 20″ x 16″ (51 x 40.5cm), collection of Mrs. Estelle Wheeler. Pfahl posed himself in the cowl to achieve an old master portrait effect in which only the face is illuminated and all else falls into deep shadow. The picture is warm throughout with hardly a cool accent anywhere. Pfahl differs from most painters who consistently paint exclusively cool or warm pictures. He alters the temperature of his colors to suit the situation, going from an all-cool painting to an all-warm one, to one in which both cool and warm elements are present.

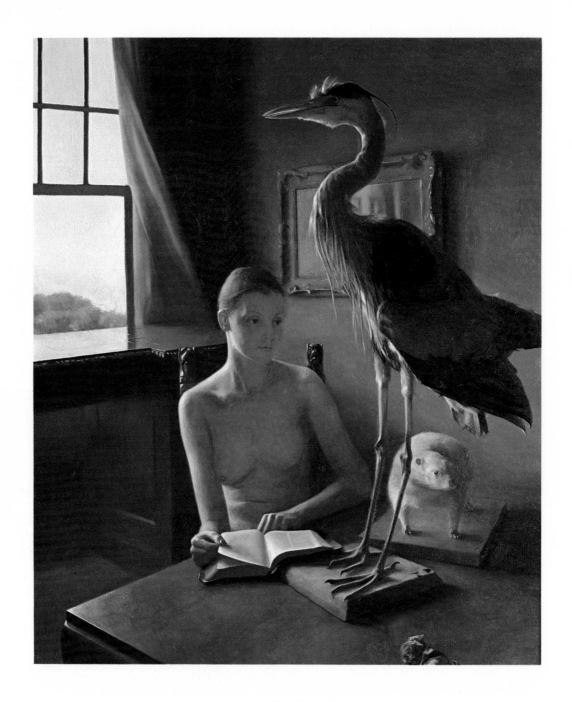

The Naturalist (above). Oil on untoned canvas, 36'' x 30'' (91.5 x 76cm), collection of Mr. and Mrs. Certilman. Pfahl had painted an earlier version of the same subject that dissatisfied him. In it, the sitter's right arm was resting on the leg beneath the table so that it appeared cut off. He then brought the right hand up onto the table, placed a book under it—obviously a Bible, which seemed appropriate to the mood of the painting. He then placed a dead rose in the right foreground. He then drastically cut down the trees showing through the window. All these major changes resulted in an almost new painting which, the artist feels, expresses his concept much more successfully.

The Naturalist (detail). The mastery of Pfahl's technique is apparent in his handling of the book. With subtle shadings he creates the illusion of the slightly toned paper, achieved with two simple dark accents that somehow provide the perfect illusion of text. Pfahl has the uncanny knack of simulating the textures of the various aspects of the subject. Every object he paints seems to emit its own individual aura and character.

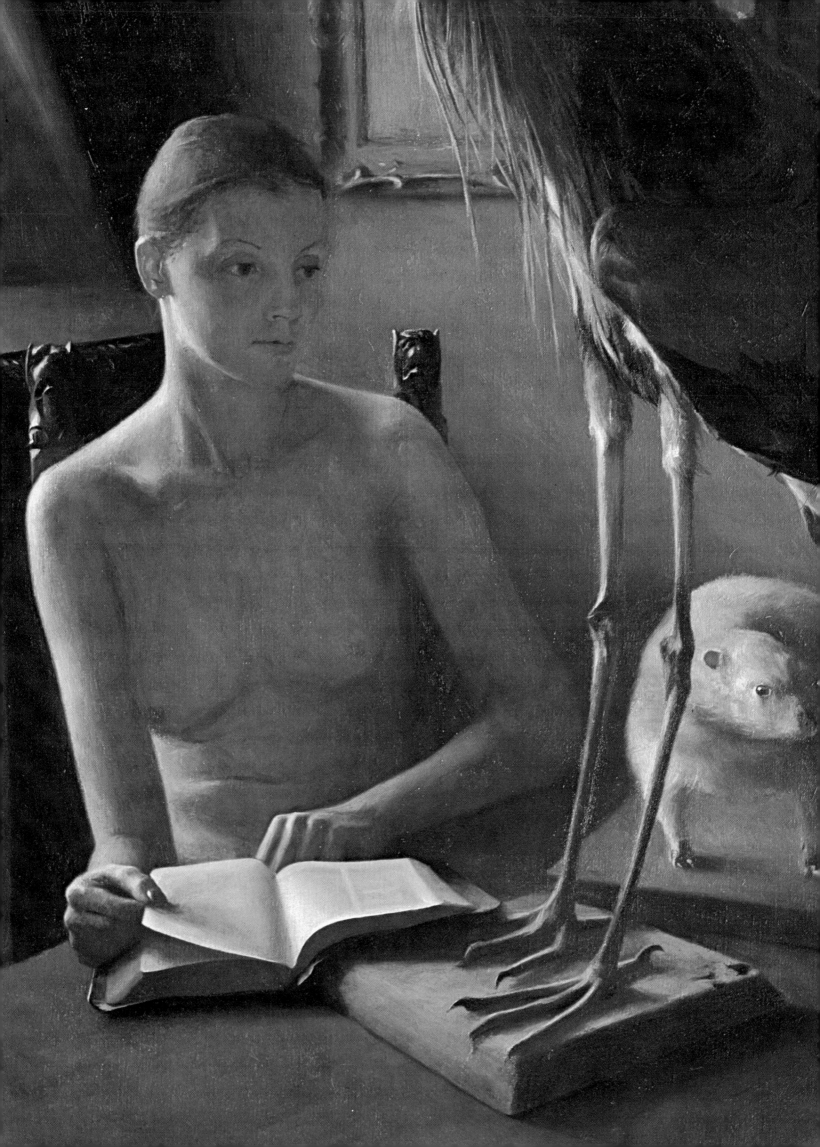

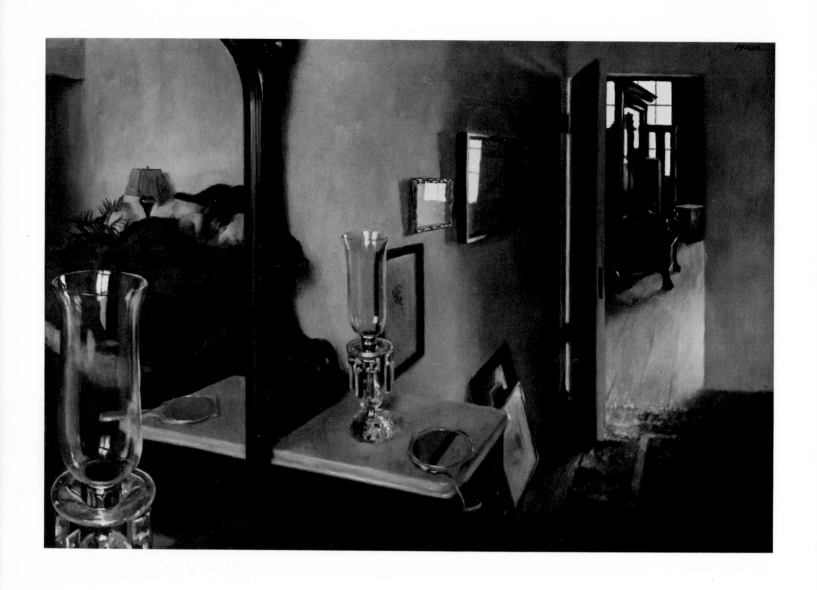

Mirrored Image. *Oil on untoned canvas, 16" x 24" (40.5 x 61cm), collection of Mr. and Mrs. A. Bressler. Here Pfahl toys momentarily with our perceptions. We are first made aware of the shapes within the room, then drawn to and through the open door to the bright window area— much in the manner of seventeenth-century Dutch paintings. It takes a while before we spot the reflection of the sleeping body in bed in the mirror on the left. The large number of reflections in the painting serve as a kind of repetitive motif that ultimately leads us to the shape of the figure on the bed.*

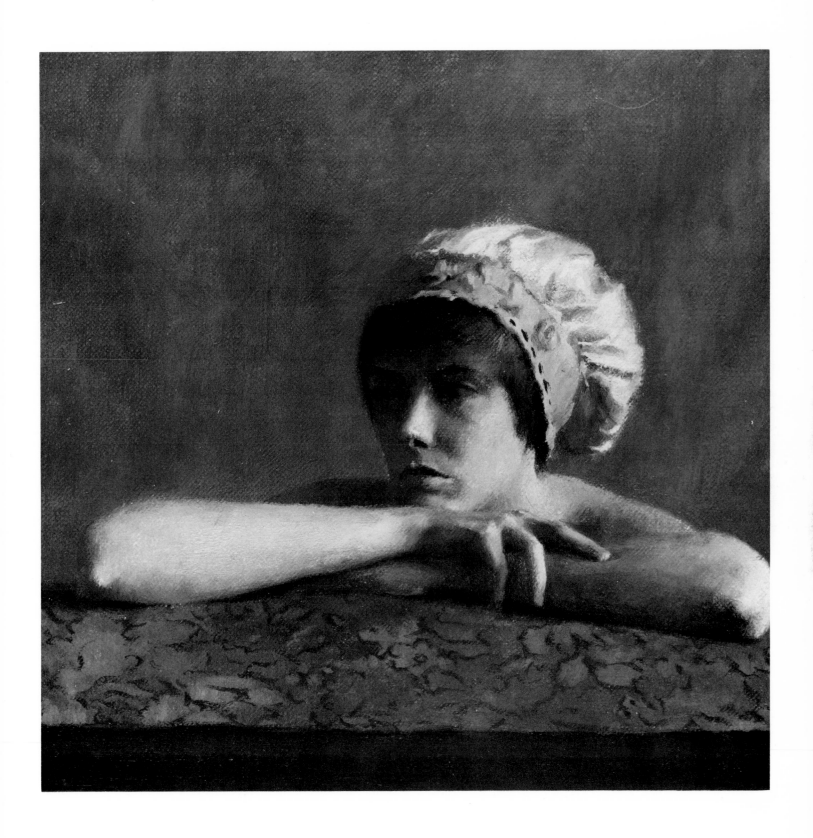

Sharon with Nightcap. *Oil on untoned canvas, 8'' x 8'' (20 x 20cm), collection of Ms. M.B. Wallace. This is a small gem of a painting, only 8'' (20cm) square. Since the head constitutes only a quarter of the length of the entire canvas, it is no longer than 2'' (5cm) in all! Yet for all its diminutive size, the head is as fully realized as in paintings five times bigger. The ability to paint skillfully in miniature requires not only good vision and a steady hand, but also a fully developed sense of design and proportion. Pfahl's ability to paint pictures of greatly divergent size reveals his great flexibility.*

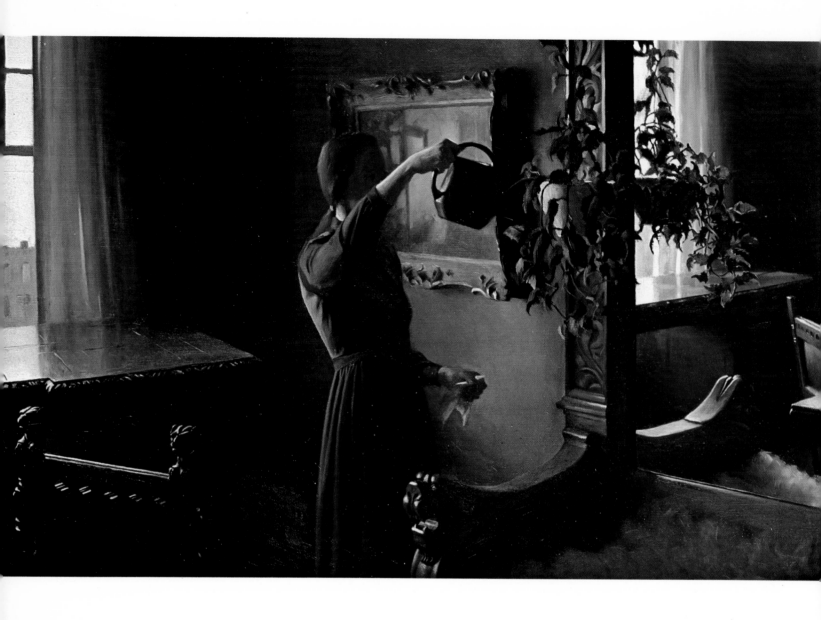

Watering Plants. *Oil on untoned panel, 18'' x 24'' (45.5 x 61cm), collection of Mrs. Dorothy Schneiderman. The powerful light issuing from the window creates an interesting counterpoint to the light reflected back from the mirror. The woman's dress provides a bright purple and green accent which picks up some of the colors of the furniture and the passion plant she is watering. Pfahl paints in the tradition of the seventeeth-century Dutch interior painters who, with exquisite technique, showed people performing ordinary household tasks in a serene, domestic atmosphere.*

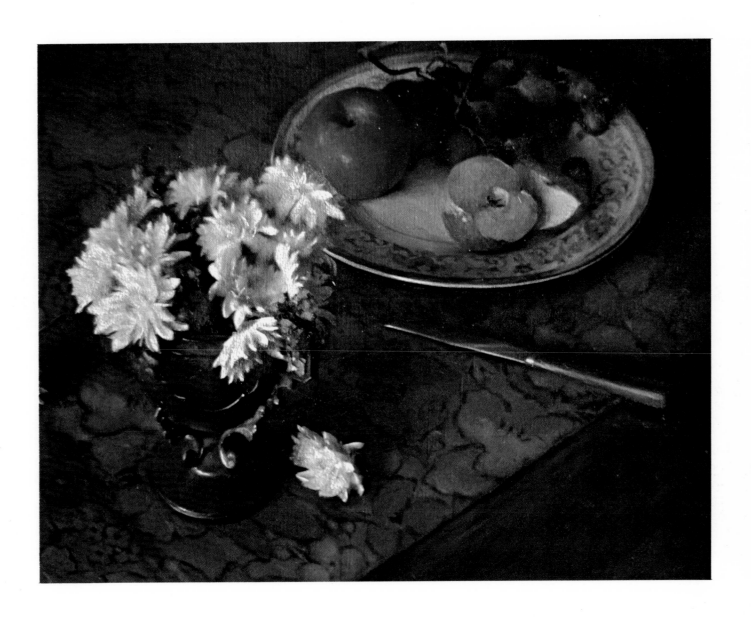

Still Life: Flowers and Fruit. *Oil on untoned canvas, 14" x 18" (35.5 x 45.5cm), collection of Mr. and Mrs. Louis Moskowitz. This is one of the few flower paintings Pfahl has executed. Pfahl was intrigued by the stark white of the chrysanthemum blossoms set against the deeper tones of the fruit. He glazed down these latter areas to keep down their value and to provide an even sharper contrast to the mums. Pfahl had avoided this subject matter in the past, but he now plans a very large flower painting. As in almost every picture he paints, the values range from a very light light to a very dark dark, which produces paintings of great dramatic impact.*

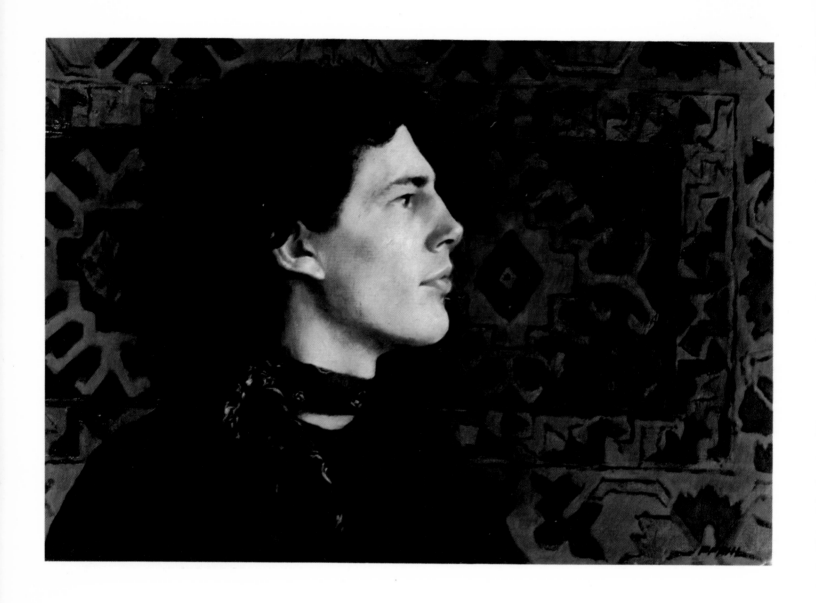

Head in Profile. *Oil on untoned board, 12'' x 16'' (30.5 x 40.5cm), collection of Mr. R. Klimo. The Oriental rug appears once again in this powerful study of one of Pfahl's favorite models. The young man's profile is reminiscent of an ancient Roman coin. The modeling of the features is subtle, and the range of tones in the head comparatively narrow. The cool accents in the upper lip, chin, temple, and just above the brow contrast with the warms of the lips, cheekbone, and the wing of the nostril. The hair is handled as a soft, dark mass with no discernible outlines where it fades off into the pattern of the rug.*

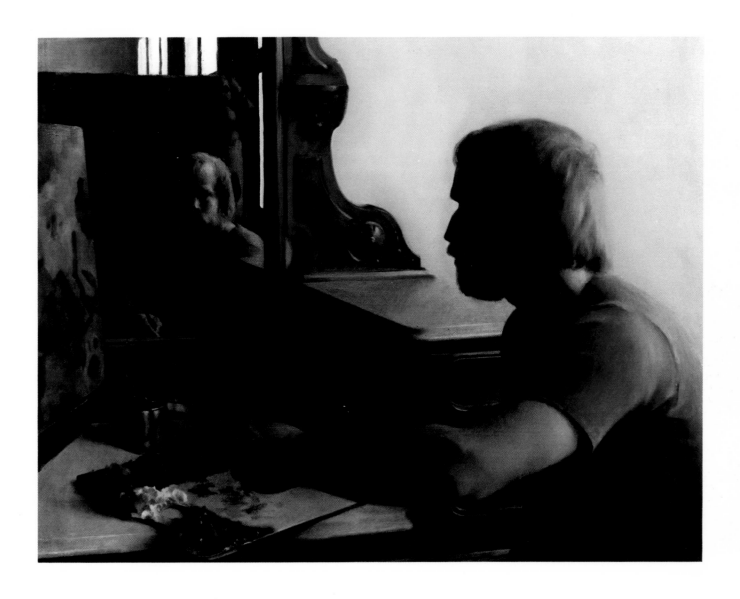

Self-portrait in Progress. *Oil on untoned canvas, 16" x 21" (40.5 x 53.5cm), collection of Mr. Jack Paramore. This represents a different version of the pose arranged in* Artist at Work on Self-portrait *(on page 104). Everything is the same except for the angle from which the artist painted himself and the change of shirt. The painting provides a clear view of his palette, with the paints piled high on the sides and the small mixing area in the middle. It is too bad some of the old masters did not leave such paintings—they would have settled the long-smoldering controversy regarding the colors included in their palettes.*

Bibliography

Bates, Kenneth. *Brackman, His Art and Teaching.* Noank, Connecticut: Noank Publishing Studio, 1951.

Hawthorne, Charles W. *Hawthorne on Painting.* New York: Dover Publications, 1938, 1960 (paperback).

Henri, Robert. *The Art Spirit.* Ryerson, Margery A., editor. Philadelphia: J.B. Lippincott Company, 1960 (paperback).

Longhi, Roberto. *Le Caravage.* Aldo Maetello, editor. Milan, 1952.

Mayer, Ralph. *The Artist's Handbook of Materials and Techniques*, 3rd revised edition. New York: Viking Press, 1970. London: Faber & Faber, 1964.

Nagel, Otto. *The Drawings of Käthe Kollwitz.* Translated from the German by S. Humphries. New York: Crown Publishing, 1972.

Nicolaides, Kimon. *The Natural Way to Draw: A Working Plan for Art Study.* Boston: Houghton Mifflin Company, 1941, 1975 (paperback).

Salomon, Jacques. *Vuillard.* Paris: La Bibliotheque des Arts, 1961.

Index

Afternoon Rest: demonstration, 42–52; finished painting, 51; studies for, 42
Afternoon Nap, 128
Arranging: interiors, 15; interior with figure, 15, 18; still life, 18
Artificial light, 20
Artist and Model, 124–125
Artist at Work on Self-portrait, 104

Backbone, 117
Backlight, 110
Barclay easel, 31
Bibliography, 141
Black Lace, 105
Bowling alley wax, 38
Brackman, Robert, 24
Brushes, 31
Butcher's wax, 38

Canson Mi-Teintes pastel paper, 31
Canvas, preparation of, 28, 31
Canvas, selecting, the, 18–19
Charcoal, placing shapes with, 33
Charlotte with Patterns, 111
Cleaning, 30
Clothed female figure (demonstration), 53–63
Color, 23–25, 28: approach to, 24; key, 25; palette, 23–24; in pastel, 24–25; warm and cool, 25
Color impact sketches, 28
Color lay-in, 34

Colors, 28; tastes in, 20
Commencing to paint, 34, 36
Composition, 18
Concept, The, 13–14
Constructing the painting, 33
Contrast in colors and values, 20
Conversation, 114
Cool and warm color, 25
Correcting the elements, 34

Demonstrations, 41–101
Depressed, 123; study for, 122
Design, 18
Despair, 112–113
Despondent: demonstration, 83–93; finished painting, 93; study for, 83
Developing the concept, 13–14
Diego, 121
Drawing with pastel, 37

Early Morning, 109
Easels, 31
Electric light, 20, 22
Elements: reestablishing the, 34; refining the, 34
Eliminating ideas, 13
Environment as a source of ideas, 13
Evaluation of preliminary work, 34

Female nude (demonstration), 42–52

Figure in an interior (demonstration), 64–82
Figure studies, 14–15
Finishing the frame, 37–39
Finishing the painting, 36
Foreword, 9
Framing, 37–39; finishing, 37–38
French easel, 31

Gilder's clay, 38, 30
Glazing, 36
Gold leaf, 38–39

Hall Mirror, 35
Head in Profile, 138
Henri Roche pastels, 25

Ideas for paintings, 13–14
Impact sketches, 28
Interior: demonstration, 94–101; finished painting, 101
Interior (demonstration), 94–101
Interiors: arranging, 15; with figure, 15; with still life, 18

Jay, 29

Key, 25

Lay-in: color, 33; tonal, 33
Lighting: daylight, 20, 22; electric, 22; manipulating the, 22; outdoor, 23

Lighting the subject, 20, 22–23

Male nude (demonstration), 83–93
Maroger medium, 28, 33; formula for, 32; using the, 36
Masonite, 31
Materials, tools and, 28, 31–32
Medium, 32. *See also* Maroger medium
Metal leaf, 38, 39
Mirrored Image, 134
Model at Rest, 21
Model, working with the, 14–15

Naturalist, The, 132–133
Natural light, 20, 22
Night Light, 12
Nude, 17; study for, 16
Nude on Carpet, 27; study for, 26
Nude on Quilt, 106–107

Observation, for ideas, 13
Oil painting: lay-in, 33; placing shapes, 33; surface, 33; toning, 33
Outdoor light, 23
Outdoor painting, 23

Painting in oil, 33–34, 36
Painting outdoors, 23
Palette, 31
Palette of colors, 23–24

Pastel: color in, 25; drawing with, 37; painting vs. drawing, 24–25; surface, 37; technique, 37
Pastel box, 31
Pastel Study, 118–119
Planning the painting, 13–28
Portrait Against Oriental Rug, 102
Posing and composing, 14–15, 18–19
Preliminary work: color sketches, 28; painting, evaluation of, 34; studies, 19; before painting, 13–28
Process of painting, 34, 36
Process of selection and elimination of ideas, 13

Rabbitskin glue, 38
Reclining Figure: demonstration, 53–63; finished painting, 63; study for, 53
Refining the painting, 34
Reflection, 120
Resting Model, 129
Richards, Jack, 24
Roche, Henri, pastels, 25
Rottenstone, 38–39

Sea Urchin, 126
Selecting: the canvas, 18–19; ideas, 13; the pose, 14–15
Self-portrait with Monk's Cowl, 131; study for, 130
Self-portrait in Progress, 139

Setting for ideas, 13
Shapes, placing with charcoal, 33
Sharon with Nightcap, 135
Still life, setting up a, 18
Still Life: Flowers and Fruit, 137
Still Life: Rabbit, 127
Still Life with Plants, 108
Studies, 14–15; for *Afternoon Rest*, 42; for *Depressed*, 122; for *Despondent*, 83; for *Nude*, 16; for *Nude on Carpet*, 26; for *Reclining Figure*, 53; for *Self-portrait with Monk's Cowl*, 130
Study in Light, 115
Study in tones, 19
Summer Evening, 116
Sunday Morning, 10
Sunday Times: demonstration, 64–82; finished painting, 82
Surface; choosing the, 33; pastel, 37
Surfaces, 28, 31

Technique, pastel, 37
Thumbnail sketches, 19
Tonal lay-in, 33
Tonal study, 19
Toning, 33
Tools and materials, 28, 31–32

Warm and cool color, 25
Watering Plants, 136
Wolff's carbon pencils, 31

Edited by Bonnie Silverstein
Designed by Bob Fillie
Composed in 12-point Vega by Publishers Graphics, Inc.
Printed and bound in Japan by Dai Nippon